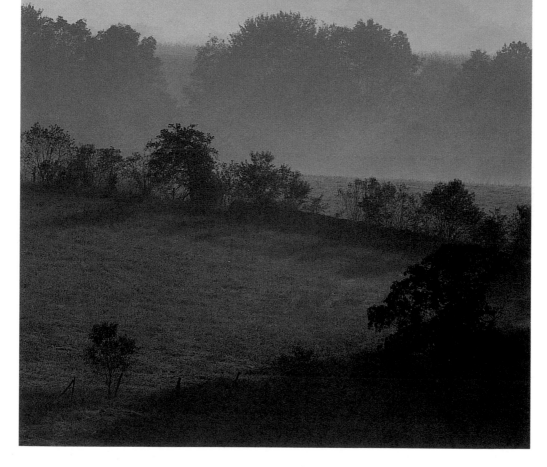

# Creative
# Landscape
# Photography

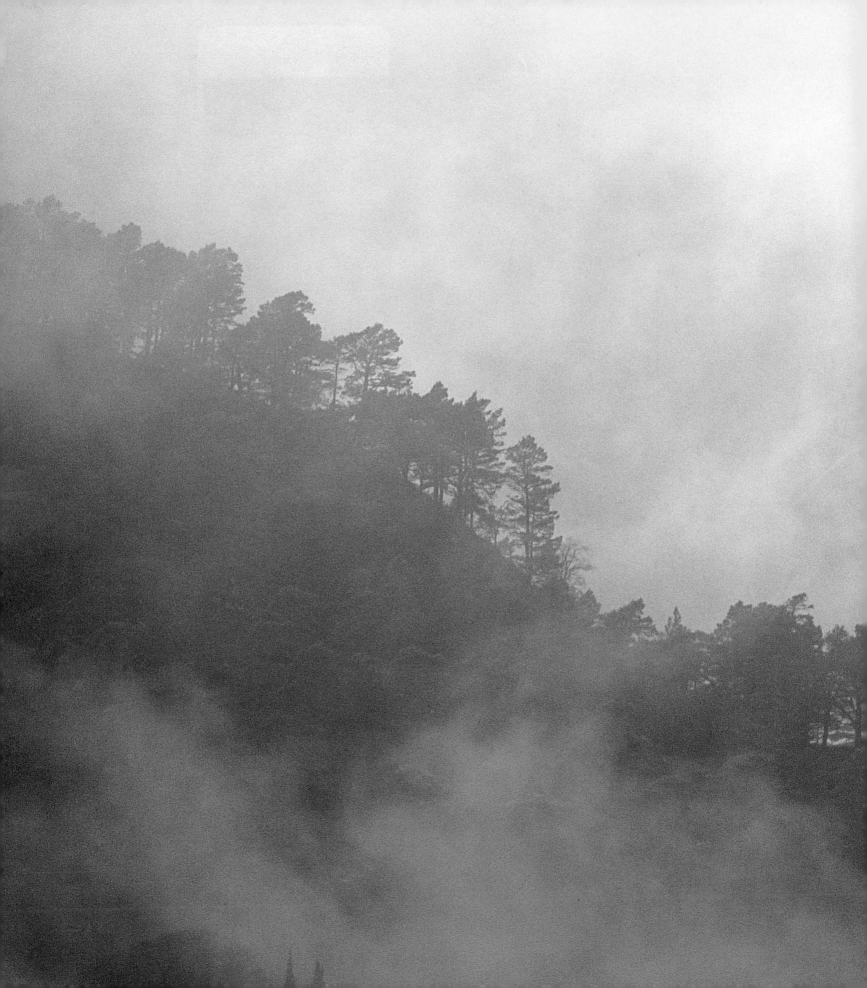

# Creative
# Landscape
# Photography

## Niall Benvie

David & Charles

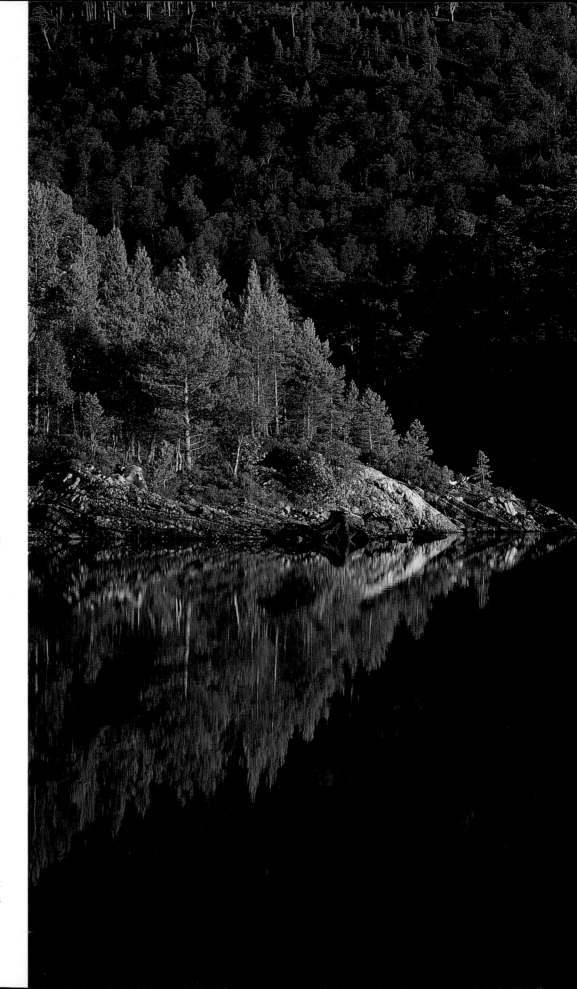

To my son, Eliot.
Here are some of the places
I want to show you.

A DAVID & CHARLES BOOK

First published in the UK in 2001
First paperback edition 2003

Copyright © Niall Benvie 2001, 2003

Distributed in North America
by F&W Publications, Inc.
4700 East Galbraith Road
Cincinnati, OH 45236
1-800-289-0963

Niall Benvie has asserted his right to be
identified as author of this work in
accordance with the Copyright, Designs and
Patents Act, 1988.

A catalogue record for this book is available
from the British Library.

ISBN 0 7153 1622 2

Printed in China by Dai Nippon
for David & Charles
Brunel House    Newton Abbot    Devon

Commissioning Editor  Anna Watson
Desk Editor  Freya Dangerfield
Art Editor  Diana Dummett
Production Kelly Smith

Visit our website at
www.davidandcharles.co.uk

David & Charles books are available from all
good bookshops; alternatively you can contact
our Orderline on (0)1626 334555 or write to us
at FREEPOST EX2 110, David & Charles Direct,
Newton Abbot, TQ12 4ZZ (no stamp required
UK mainland).

# Contents

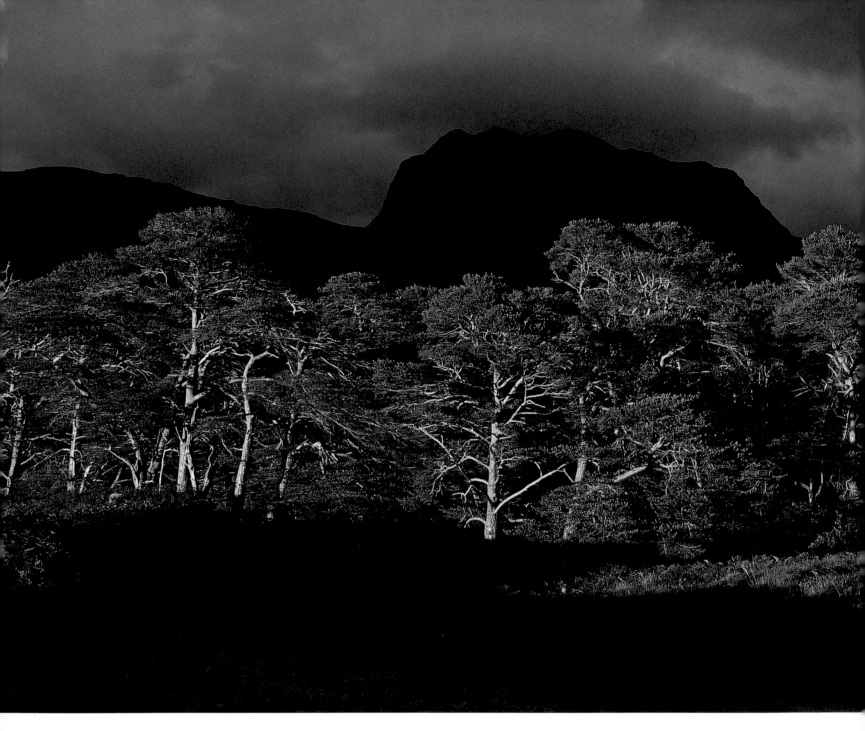

**The close of day**

*When I look through my picture library, I often ask myself 'Was I really there? Did I really see that?' In these situations, picture-taking becomes purely reactive. In this instance, there was no premeditation other than identifying the location earlier in the day. Darkness engulfed the scene just 10 minutes after the picture was taken.*

HASSELBLAD XPAN WITH 45MM, CENTRE-SPOT ND FILTER, FUJI VELVIA

# Setting the Scene

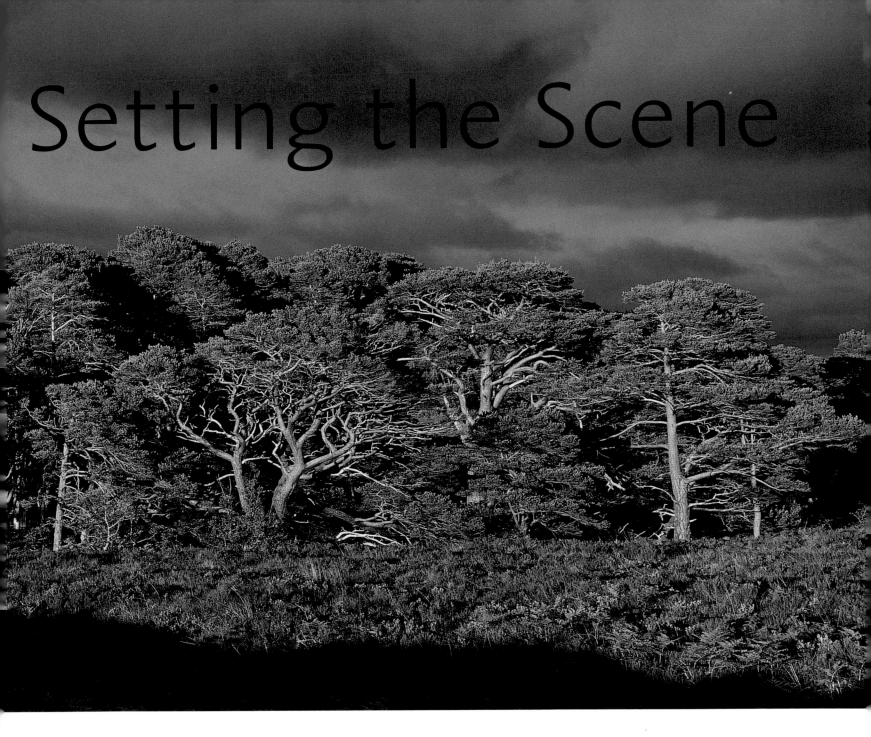

*The voyage of discovery is not in seeking new landscapes but in having new eyes . . .* Marcel Proust

AFTER the intricacy of summer, snow had brought a starkness to the Polish forest, its forms simplified and shadowless on this overcast day. Every so often, a great spotted woodpecker punched holes in the brittle air. We walked through the still, snow-bowed forest for a long time, crossing a bison trail and wondering if wolves had shared with us this easy way through the oak, hornbeam and lime. Suddenly, I stopped and exclaimed to my companion, 'This is it!' Ahead the path forked, its divergence more clearly defined, even in this flat light, by the earlier passage of a ranger's vehicle. A mental image had suddenly and powerfully been realized before my eyes and could now be set down in a photograph (see page 115).

This reactive approach to landscape photography is, for most of us, the norm. We respond to certain visual cues – a particular landform, a certain type of light – by taking a photograph. In doing so, we satisfy a profound need to bring order to wild nature. The resulting image recounts, with varying degrees of success, the photographer's experience. This book presents a mixture of the reactive and

creative pictures. Many are simply about the appearance of things, uncomplicated by metaphor, celebrating the union of light and land. Others go one step further. The aim of this book is to encourage you to take that step with me, to think creatively.

A 'creative' photograph is distinguished, I believe, by *intent* on the part of the photographer. Just before I visited the Polish forest I had been reading, again, Robert Frost's well-known poem, 'The Road Not Taken'; thus, the reaction I had to the scene could be accounted for not so much by the light and forms before me as by an idea already formed in my mind. The photographer's opinions, beliefs and experiences colour all of his/her work, but in creative photography there is a clear intent to set out some of these ideas in the photograph. The whole process becomes more deliberate and conscious. This can be dangerous territory for those of us who profess to put honest representation of the natural world ahead of personal agendas: just when does an image stop being about nature and instead become only about the photographer?

As the person fired up with ideas and creating the pictures, it is easy to forget that a picture's only meaning is that given to it by the viewer. So, while we may want to make a particular statement, if the viewer chooses to interpret the picture differently there is nothing we can do about it.

Here is a further example of the problem of 'creativity' for nature photographers. I shot the shattered ash tree in the picture on the right purely as an exercise in aesthetics; I thought that it would make an attractive sunset silhouette. The image was pre-planned, but the intent was only to make the picture look as dramatic as possible. In style and approach, the

**Scots pine**

*Irrespective of my own intent in this photograph, the viewer may choose to see this (very bleak) picture as nothing more than a shapely silhouette with a nice sky.*

55MM, FUJI VELVIA

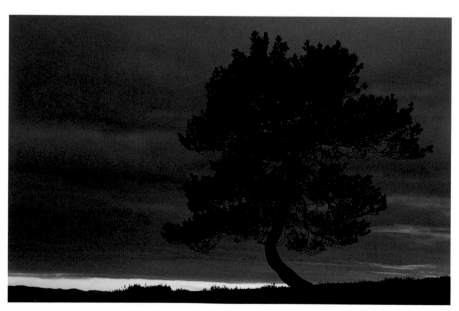

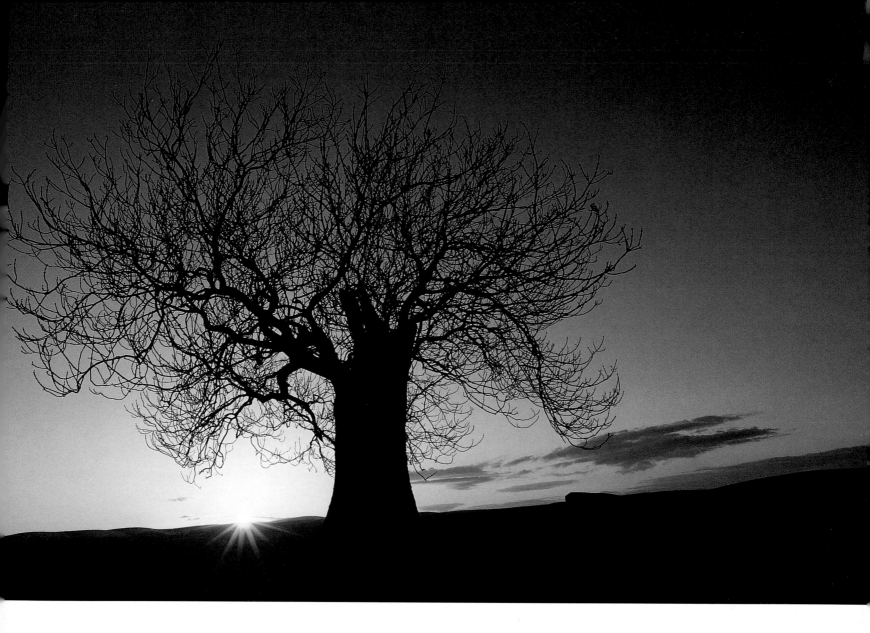

picture of the pine on the left is indistinguishable from that of the ash, yet this time there was an entirely different thought process in action, making this photograph – by the definition of intent – a creative one. Earlier that year I had travelled in western Norway and been impressed by the extensive wild forests of Scots pine, a habitat which, through climatic deterioration and human assault, has been reduced to dislocated scraps and remnants in my native Scotland. The single tree on a hill near home represented that loss. Its portrayal

as a silhouette, the bowed trunk and the open space all around each lend their own metaphorical weight to the idea. The red sky is used as a visual hook to engage the viewer's attention.

Just as it is disingenuous of a photographer to provide an interpretation of his/her image which wasn't in mind at its conception, so too should the viewer accept that some photographs cannot be taken in at a glance, and that their content is greater than the sum of their aesthetic parts. In other words,

**Ash**

*This picture was previsualized as simply an attractive sunset silhouette. The viewer may read a metaphorical content, but I can claim none.*

20MM, FUJI VELVIA

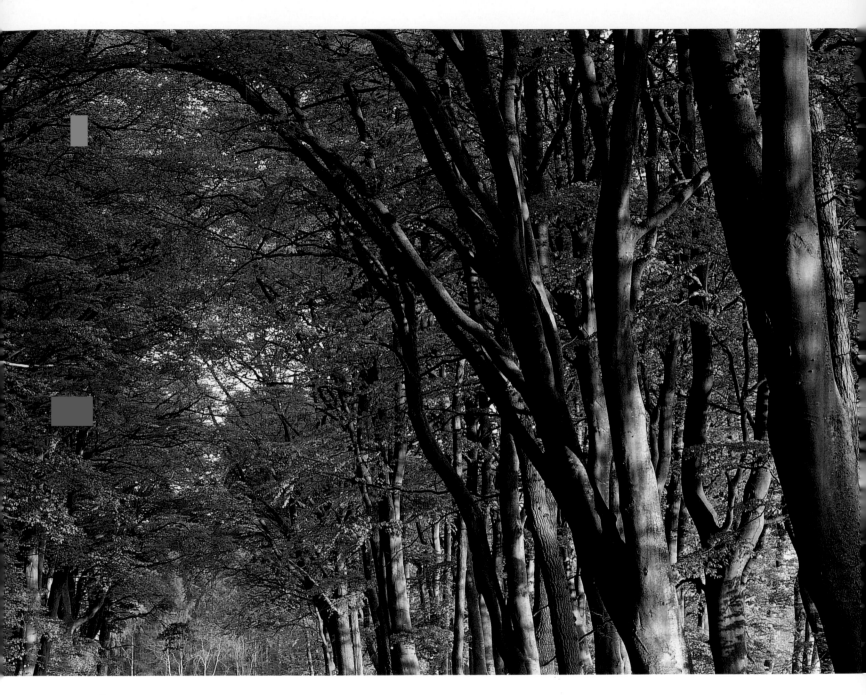

**Beeches**

*The sacred grove, where the form of the trees echoes the structure of a cathedral (or vice versa. . .), is an idea that appears in numerous paintings of the Romantic period, with associations of resurrection and rebirth. The shapes are as alluring to photographers, even if we are less conscious of the metaphor.*

90MM, FUJI VELVIA

landscape photographs may tell a story as well as describe a scene. Our task, in stating what we feel about the natural world, is to set out the story as lucidly as we can. That way, there is a better chance of our intention and the viewer's interpretation meeting one another; a landscape photograph is a bridge between our experience of a place and a viewer's understanding of it, so we should try to keep it as clear of obstacles as possible.

In this book, the traditional definition of landscape photography has been stretched to include urban environments and details of the elements that combine to form the greater landscape. In *The Art of Nature Photography* (David & Charles, 2000), I characterized the divide between the space occupied by wild animals and ourselves as one between an 'inner country' and an 'outer country'. While the wildlife photographer searches for ways into the inner country, the landscape worker is chiefly concerned with the outer, a characteristic of which is its accessibility. Elemental details and man-made environments belong as much in this space as do mountains and oceans.

It is a mistake, however, to imagine that easy access to the subject makes for easy photography. In his Gaia hypothesis, Dr James Lovelock popularized the idea of the world as one enormous organism, and landscape photographers are intensely aware that the outer country is not inert; like a living thing, its aspect and disposition are constantly changing with the light, the time of day and the season. In coastal areas, tidal action introduces another set of dynamics; in high mountains, a relationship with clouds adds further variety. So, while the landforms may be static, their appearance is forever changing. A lesson we learn early on is that each special conjunction

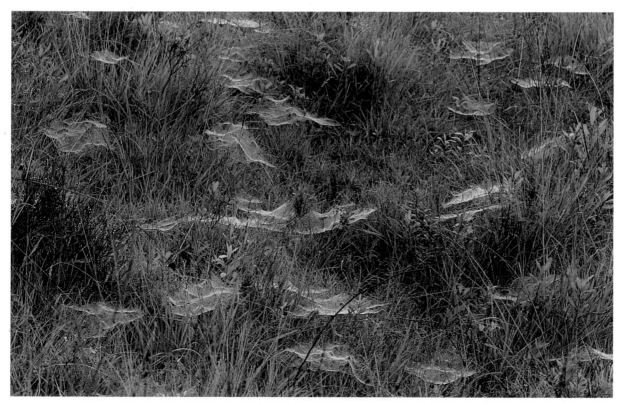

**Cobwebs**

*Sometimes the photographer's emotional reaction to a scene is better conveyed in close-up than in a grand vista. In the cool tones of this shady marsh, we can also see that in the open it is a sunny morning, the blue sky reflected in the pale webs.*

90MM, FUJI VELVIA

of colour, light, shape, texture and form in the landscape is unique and can never be relied upon to repeat itself.

Perhaps it is this beguiling mix of easy access (compared to locating and getting close to wild animals) and unending variety that makes landscape such a popular topic for photographers. And while these attributes form the attraction, our lack of control over natural light provides the challenge. As more and more 'wildlife' photography is carried out under controlled or contrived conditions, there is still a 'First Morning' purity (illusory or otherwise) to a successfully executed landscape photograph.

Although digital enhancement and manipulation is now used frequently in wildlife photography, few landscape photographers have yet exploited the technology. Chapter 11 provides case studies in which the computer has been used to illustrate a concept or as a means to overcome shortcomings of the medium. For those of you who may be anxious about the mixing of silver halide and pixel, be assured that beautiful light, with all its subtlety and variation, cannot be created in the computer. There is no substitute for being out there. And the love of being out there is the first prerequisite for successful landscape photography.

The influence of the Romantic school of landscape painting (painters, incidentally, who got out and experienced the elements) on contemporary landscape photography is probably more profound that most of us realize. The popular photographic topics of sunsets, wild seas and brooding skies all appear in the works of Turner and Caspar David Friedrich. Later, portraying the ephemeral aspects of the landscape concerned Cézanne as much as it does today's photographers chasing the light. Renoir painted *Le Coup de Vent*, in which the

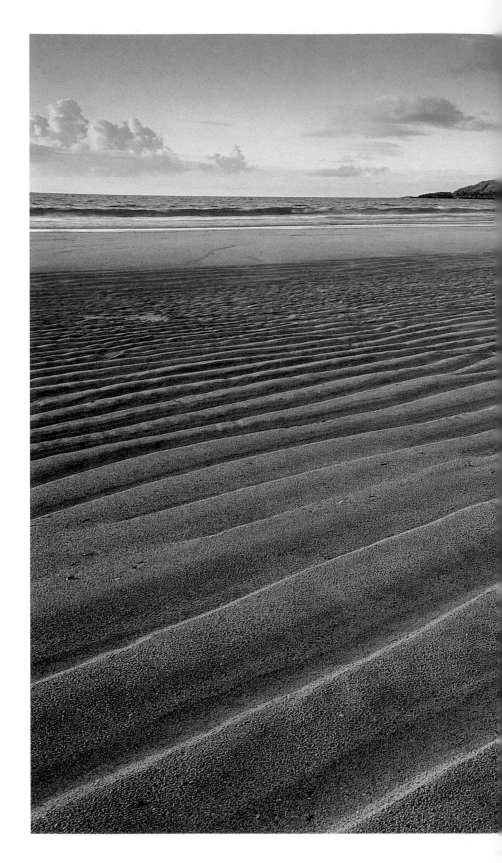

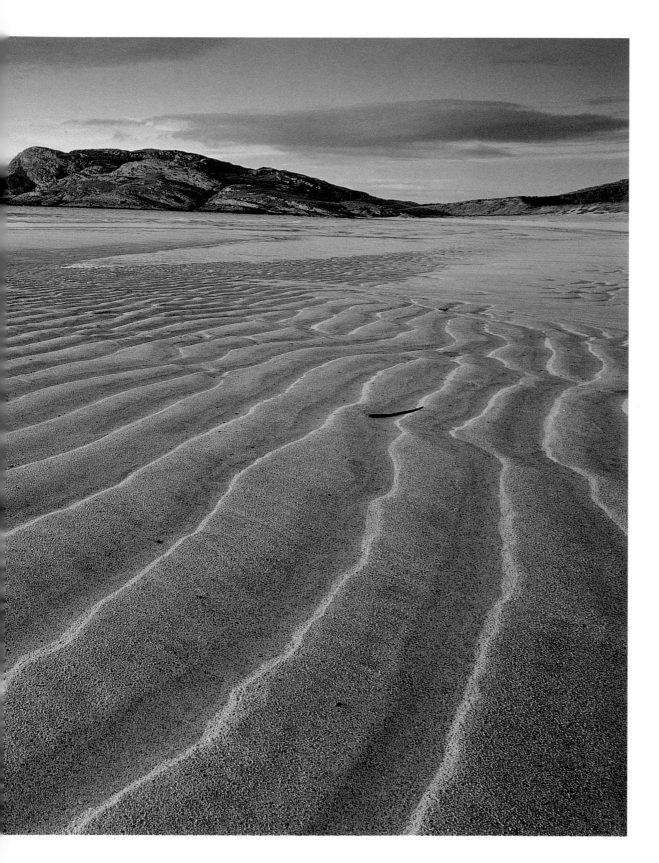

### The advance of the Atlantic

*35mm cameras are versatile and fast to use in comparison to larger formats. Here I was working not only with rapidly changing light as sunset approached but also an advancing tide, which very soon after swept over the beach to cover these ripples.*

20MM, −2 STOP
HARD-STEP ND FILTER,
FUJI VELVIA

foreground vegetation has moved during a gust of wind, long before we thought to use long exposures to achieve the same effect. And, as we shall see in Chapter 3, the panoramic image, today riding a wave of popularity, has the most ancient pedigree of all.

A study of Western landscape painting, even before the eighteenth century, reveals a growing preoccupation with authenticity, with representing nature accurately. Later, this coincided with advances in the understanding of the natural world through the work of scientists such as Lyell and Darwin. In his book *Landscape and Western Art*, Malcolm Andrews quotes the French painter Claude-Joseph Vernet, writing in 1765, 'You must do exactly what you see in Nature; . . . you must render it as you see it; for, if it is good in Nature, it will be good in painting.' This is a sentiment echoed by most landscape photographers today, yet our view of nature is often a very selective one, making no clear reference to the presence or influence of people in the landscape. The slow, reluctant recognition of people as part of nature, which began in the nineteenth century, is today universally understood, though too often unacknowledged in our treatment of the natural world or pictorial representation of it. For the creative landscape photographer, there can be no more compelling story to tell than that of the need to respect the natural systems upon which we ultimately rely.

### In living colour

That colour has largely replaced black and white in landscape photography can be seen as a reflection of a wish to be at one with the subject. Represented in black and white, the landscape is imbued with an abstract quality, held at a distance from our sensory experience of it. It is made unfamiliar. Creative monochrome landscape work has traditionally been as much about the process of image creation as the photographer's experience of place, with colour a vulgar distraction from the forms which are pre-eminent in black and white work. Among fine art photographers (Eliot Porter and Ernst Haas being two notable exceptions), colour was disparaged as a snapshot medium because in comparison to black and white it afforded only limited control over the final print. The digital revolution has changed all that, offering workers in both black and white and colour an unprecedented level of creative control.

All the pictures in this book were taken on 35mm film, either as 24x36mm or 24x65mm shots. Digital capture can yield pictures of comparable quality, but I, for one, am unclear as to whether the means to view digital files made today will be available in 20 years' time. I believe this matters – fine photography is enduring, and beautiful light itself deserves to be treated as something better than a mere consumable. Compared to a digital file, a piece of 35mm film is cheap, holds lots of information and needs no special equipment to see it. This format does not boast the extensive negative area of larger ones, so when the pictures are greatly enlarged they do not look as sharp as a landscape shot on 5x4in. Nevertheless, there are some compelling reasons, elaborated on in Chapter 10, for 35mm to be accepted as a serious format for creative landscape photography.

One of the traditional appeals of shooting on medium and large format has been its impressiveness on the lightbox; the 'miniature format' just cannot compare. But as more and more picture viewing and sales occur on-line (a

trend sure to continue since it is easy, cost-effective and fast), fewer and fewer of these original, glorious pieces of film will actually be seen by the end user. Other considerations, such as the size of the image file required to store all the information on the film, come into play. A high-resolution scan from a medium or large format piece of film creates a huge file in comparison to one made from a 35mm transparency or negative. This has cost, storage and distribution implications. If we want to work on a large format scan in-computer, we will need a faster processor, more RAM, a massive hard drive, and will be obliged to invest in an expensive drum scanner if we want to resolve all the detail and tonality of the original. Even then, there is no saying that its absolute quality will be evident when the picture appears in print.

With good technique, sharp lenses and fine film, 35mm is capable of producing the quality we need for most uses. What is most important, by far, is your vision of the natural world and your ability to share it.

**Where the sea meets the land**

*The subtlety of colour on which this picture relies for its effect is fully evident only on a light box: image reproduction, on screen or page, is always a compromise.*

90MM, FUJI VELVIA

# Exposure

**Montrose skyline**

*By using the manual exposure mode, the decision to render the town as a silhouette was made by me, not the camera, whose inclination it is to make everything mid-tone.*

300MM + X1.4 CONVERTER, EKTACHROME PANTHER (LUMIERE) 100X

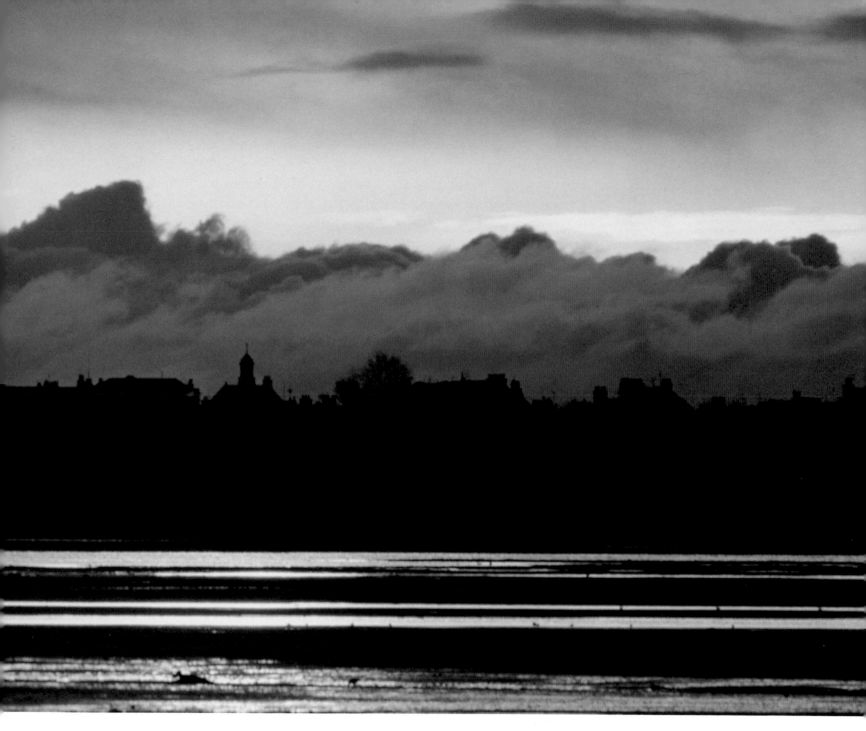

Most photographers can agree on two things: pictures that are meant to be sharp should be sharp, and they should be correctly exposed. These are the essential technical criteria for a successful photograph, and no matter how great the lighting or inspiring the landforms, an under-exposed, blurry picture looks best in the bin. Well, here is a problem straightaway. While focus is easy to define in terms of the diameter of circles of confusion, the definition of 'correct' exposure is altogether more arbitrary, especially in respect of landscape photography. Let's talk instead about 'good' exposure – the one that looks best to you.

ARRIVING at a good exposure relies as much on an understanding of the limitations of film as it does on knowing how to take light readings. As we look around a forest on a sunny summer's day, we are confronted by enormous tonal variations, from deep shade to brilliant sky. Two processes occur simultaneously: our eyes constantly adjust to the amount of light reflected into them, allowing us to see detail on the underside of a bracket fungus and, a moment later, white gulls winging across a blazing white sky. At the same time, our stored memory of how the world looks is feeding information out, filling in the details that we don't consciously perceive but which our experience tells us are there. Our visual system is therefore vastly more sensitive than film – although in very dark conditions our eyes may take some time to adjust and our imaginations may have to work a little harder.

In contrast, a modern E-6 transparency emulsion such as Fuji Velvia can record detail in a range of only about 4 stops. This means that the lightest highlights that show detail can be no more than 2 stops paler than mid-tone and that detail will disappear in tones more than 2 stops darker. The range is somewhat wider with colour negative, but if we want detail in every part of our transparency all the tones must fall within this 4 stop range set by the film. This is not to say that we shouldn't tackle landscapes with extremes of contrast; but to remind us that if we want to, we cannot expect to record on film all the detail we see with our eyes. As we will see in Chapter 11, greater contrast ranges can be accommodated by combining two or more exposures of the same composition in-computer, but let's concern ourselves here with the 'straight' image.

It will probably have occurred to you already that an informed exposure selection cannot be determined automatically. Flick the exposure mode to manual. The parameters used by the camera to define the 'correct' exposure do not necessarily coincide with those for a 'good' exposure. The camera cannot know which areas you have chosen to sacrifice so that you can preserve detail in bright highlights – or that you want to burn out the background so that the shaded foreground subject is fully detailed. In respect of exposure, automation works against creativity and too

**Scots pines in clearing fog**

*The huge contrast between the silhouetted trees and the sunlight gushing between them offered a number of exposure alternatives, none necessarily better than the others. What I actually perceived was a combination of the detail of the trees evident in the lighter image* (BELOW LEFT), *and the darker mood of the other. Bracketing covered all the options.*

55MM, FUJI VELVIA

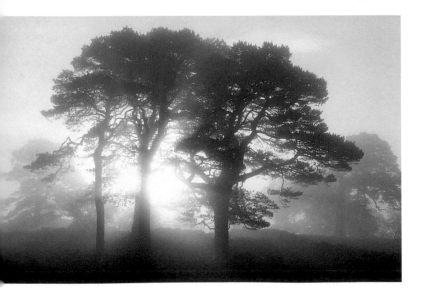
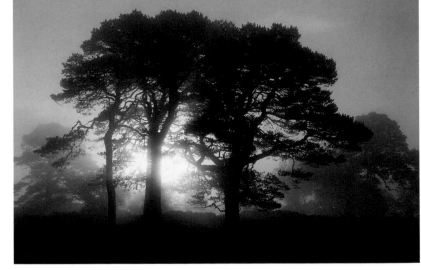

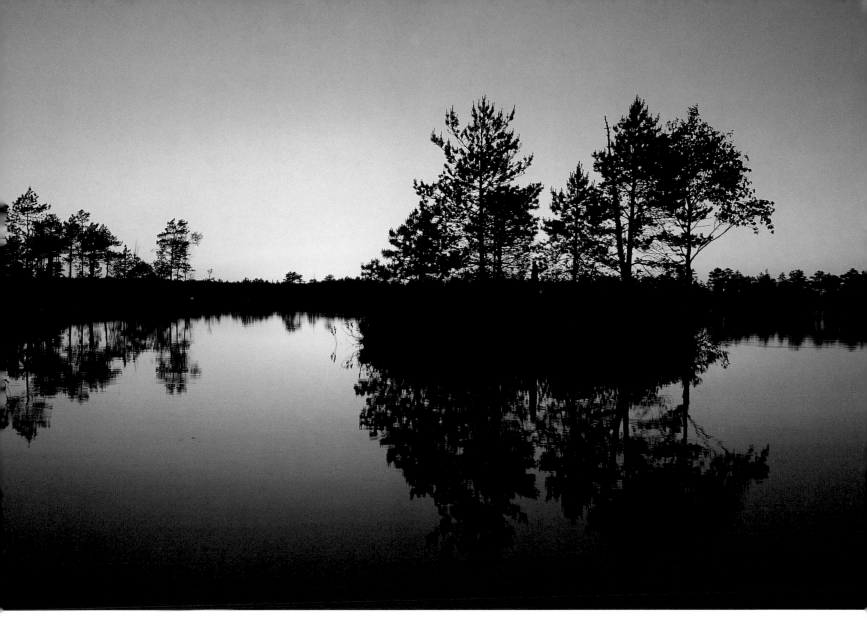

often leads to disappointment. Take control.

Many modern cameras offer a choice of three metering systems within the manual exposure mode: centre-weighted, spot, and matrix or evaluative metering. We need only the first two. Matrix metering takes readings from several sections of the frame and, through its 'experience' of the many picture-taking situations programmed into the software, tries to strike a balance between the different sections. Unfortunately, the camera does not know which is the most important

**Kemeri National Park, Latvia**

*Although a clear sky promised relatively weak sunset colours, it did at least provide an uninterrupted backdrop for the Scots pines bordering the bog pool and those on the island. I set my exposure by deciding which part of the sky should be mid-tone and metering from it. I had to make sure that it was no more than 1²/₃ stops lighter than the darkest part of the sky, since it would feature at the bottom of my picture and I did not want it to blend with the reflections of the trees.*

55mm, Fuji Velvia

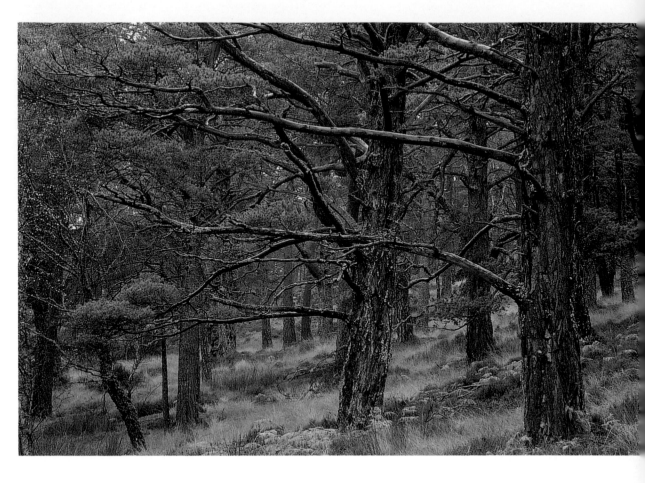

**Wet Scots pine forest**

*Flat, even lighting conditions are invariably easier to meter than contrasty ones. Here only the saturated yellow grass and bracken deviated from mid-tone. This is one situation where I would trust an automatic meter reading, although in the event I took a manual one.*

90MM, FUJI VELVIA, 81A
WARM-UP FILTER

part of the composition (although it may use distance information from the lens to guess), so it might or might not choose the right part. And even if the amount of light reflected from your subject remains constant, adjusting the composition to include more sky changes the meter reading. This is no way to achieve consistency – or to figure out what went wrong when your pictures weren't well exposed.

### CALIBRATING AGAINST MID-TONE

A camera's meter should be calibrated against mid-tone before you take it out for the first time; if not, your finely honed manual metering skills will be displayed as consistent over- or under-exposure. To do this successfully, you need to be able to identify a mid-tone.

Mid-tone, by definition, is a surface that reflects 18 per cent of the light that falls on it. Mid-tone is not necessarily grey, although the standard reference, the Kodak grey card, may lead us to suppose otherwise; it is merely an index of reflectiveness. In fact, there are mid-tones of most hues except, of course, for the achromatic colours: mid-tone black and mid-tone white are the same – grey.

Learning to identify mid-tone is a vital skill if you want to take control of exposure, because it is the point around which everything else, in exposure terms, moves. This becomes crucial when the tonal values within a scene exceed the 4 stop range that film can handle and exposure compensation needs to be applied (see pages 25–8). Study the particular

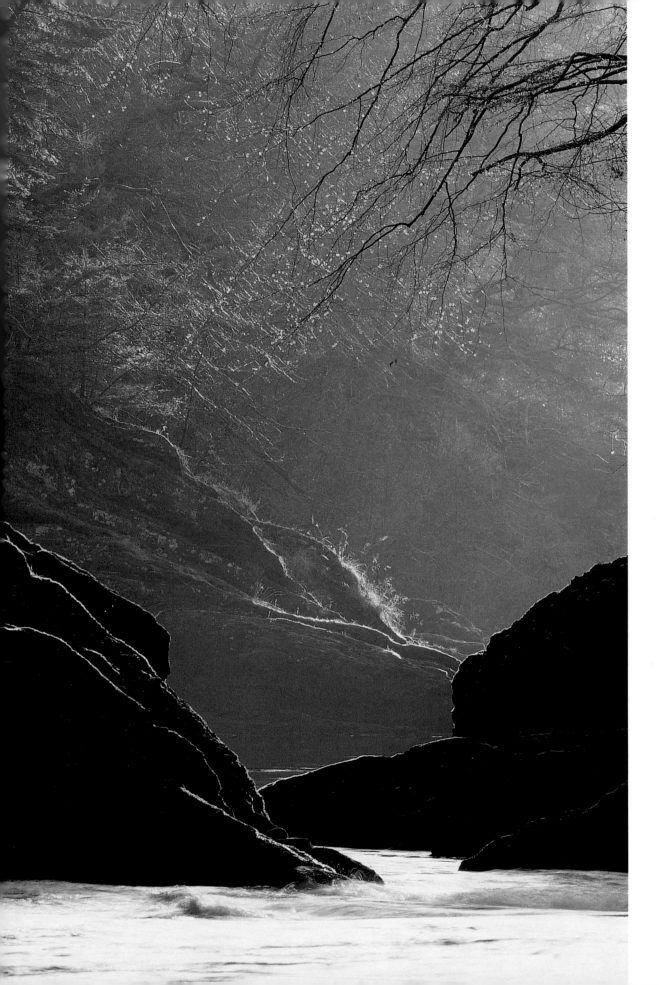

**River North Esk**

*In most Februaries, my part of Scotland experiences a false spring – up to a week of fine settled weather with mild temperatures – before a return to winter. I wanted to match the feel of this picture with the benign conditions, by over-exposing slightly for the background and losing most of the detail of the cold water.*

300MM, FUJI VELVIA

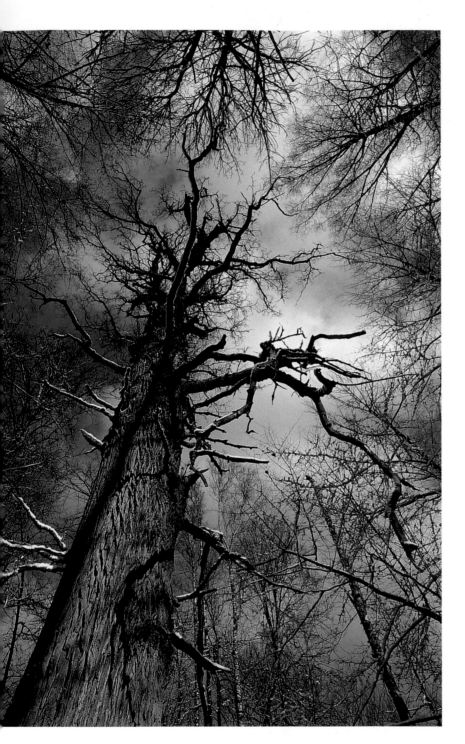
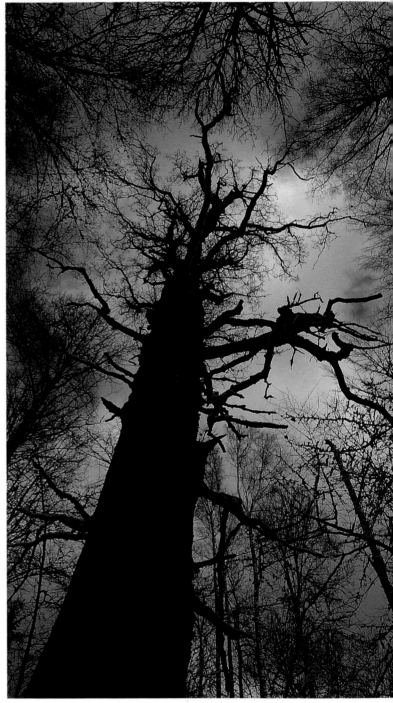

**Ancient pedunculate oak, Bialowieza, Poland**

*A characteristic of the oaks in this forest is not only their great dimensions but also the straightness of their trunks. The spotmeter reading for the illuminated tree (ABOVE LEFT) was taken from the part of the trunk in sunlight. The mood of the picture altered completely when the sun went behind a cloud and exposure was reduced by ¹/₂ stop (ABOVE RIGHT).*

28MM, FUJI VELVIA

lightness of the grey card. Note how it relates to other shades of grey and keep that relationship in mind when you look at other colours. With practice, you will develop a feel for the best shades of a colour to meter as mid-tone.

Calibration (to ensure that when the meter shows that mid-tone is 'correctly' exposed, it is) is a straightforward process. Rather than a grey card, I use a reasonably sized piece of man-made fleece of the same tonal value; I've yet to see a card that doesn't develop a glare when held at an angle to the sun. As an extra reference, you can place a familiar object, such as a film box, alongside. Conduct the test when the light is not likely to change suddenly; it can

be in sunlight or shade, but not half in, half out. With the camera on manual, centre-weighted metering and the subjects filling the frame, set the ISO dial to the nominal speed of the film and adjust shutter speed and aperture until the meter indicates a correct exposure. Then change the ISO value in $^1/_3$ stop increments, taking one frame each time and adjusting the aperture until once again correct exposure is indicated by the meter. If you are calibrating with ISO 50 in the camera, you would start off at 50, then 25 (1 stop over), 32 ($^2/_3$ stop over), 40 ($^1/_3$ stop over), 64 ($^1/_3$ stop under), 80 ($^2/_3$ stop under) and finally 100 (1 stop under). Meters are unlikely to be more than 1 stop out either way.

**Scots pines on knoll**

*Like the hill behind, I was in the shadows when an early morning shaft of sunlight struck this distant knoll of pines. The camera's built-in meter proved to be the fastest and most precise way to meter the scene; I simply took a spot reading which included some of the pines and heather, being careful to avoid the pale-coloured bracken.*

180MM, FUJI VELVIA

### Snowy summit at sunset

*Shooting directly into the sun, even when it is very low in the sky, can easily throw out automatic metering systems, especially when snow features in the picture, too. I took a centre-weighted reading from the snow and rocks on the right and went with that. Once this exposure was set, I added a graduated ND filter to hold back the exposure for the sky.*

20MM, −2 STOP HARD-STEP ND FILTER, FUJI VELVIA

Once the film has been processed, identify the setting that has given the best exposure. If it was ISO 32, for example, you would know that your camera was wanting to over-expose everything by $^2/_3$ stop. In future, set the ISO dial to this speed for this film or, if you never use automatic metering, move the ev (exposure value) compensation dial to $+^2/_3$.

## INCIDENT OR REFLECTED LIGHTMETER?

All built-in lightmeters work by measuring the light reflected from a surface. Obviously, a shell-sand beach reflects much more light than a charred piece of driftwood, yet the amount of light falling on each may be just the same. A hand-held incident lightmeter, in contrast, measures the light arriving on the scene rather than that reflected from it. On the face of it, this would seem to be the ideal method, removing the anxiety about metering off a false mid-tone. But this approach works only if everything within the frame falls within our 4-stop range, or if the main subject is mid-toned. An incident lightmeter cannot tell us if, for example, the sand is actually 3 stops brighter than mid-tone (in which case it will be burned out by 1 stop if we go with our incident meter reading). And if we are in the shaded lee of a hill, how do we take a reading of the illuminated area we are interested in, a few hundred metres away?

In practice, many of these meters act as both incident and reflected types, and the best ones provide a spot function, too. Nevertheless, you will still need to remember to factor in correction for filters you've applied and for light lost through tilting and shifting the lens. It's therefore much better, I believe, to spend time familiarizing yourself with that expensive meter you already own in the camera.

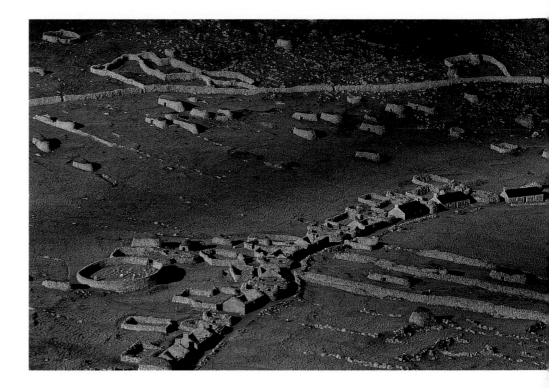

## GOOD EXPOSURE EVERY TIME

Your meter is properly calibrated and you have a good idea of mid-tone. You realize, too, that film will not see everything that you do. With this knowledge, you can make the picture look the way you want it to – but there are still some decisions to be made along the way.

With a reflected lightmeter, there are two distinctive routes leading to a good exposure. One involves taking a reading off the main subject and applying exposure compensation if it is lighter or darker than mid-tone. The other relies on finding a mid-tone area in the same light as the principal subject, then determining how much difference in exposure there is between it and the subject, and applying compensation if required. The direction in which compensation is applied is the opposite for the two methods, and if you feel intimidated by manual metering it is best to stick with just one until the process is familiar.

**St Kilda, Outer Hebrides, Scotland**

*The St Kilda archipelago's position in the north Atlantic makes it susceptible to highly changeable weather. On this May evening, clouds raced overhead, changing exposure readings almost by the second. The drystone walls and cottages were themselves a little paler than mid-tone, so I took a centre-weighted reading from the grass in full sunlight.*

180MM, FUJI VELVIA

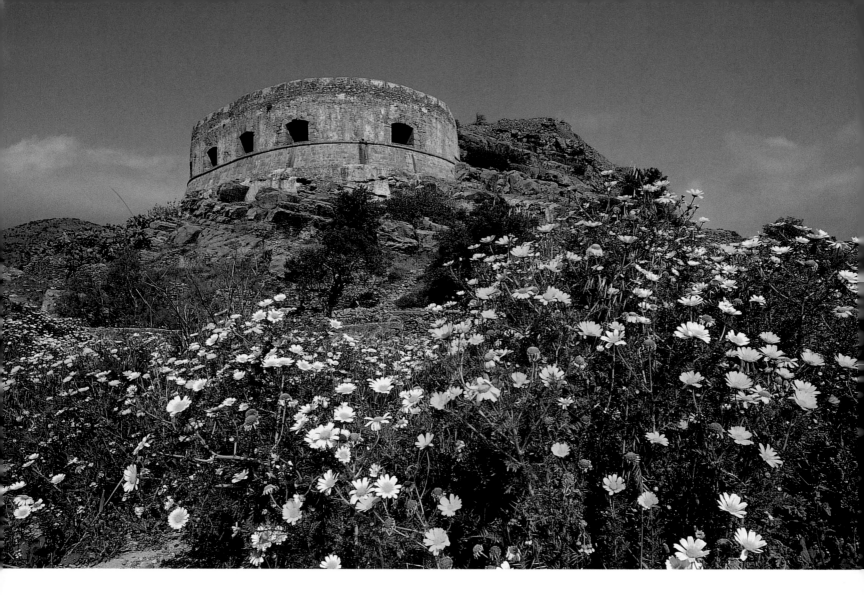

**Venetian fort and chrysanthemums, Spinalonga, Crete**

*The yellow flowers were highly reflective and in direct sunlight, so I closed down ¹/₂ stop from my mid-tone reading taken from the rocks to the right of the fort. Its honey-coloured stone – and the sky – were now also rendered more sympathetically.*

20MM, FUJI VELVIA

If you choose the first method, you mustn't forget just how unsophisticated a lightmeter actually is. Its mission is to render everything mid-tone. Meter pure white and it sees only a high reflective index, and tells you that you need a smaller aperture or faster shutter speed than the light conditions permit. White becomes mid-tone grey. The same happens in the opposite direction with black. Metering off the subject always requires you to apply varying degrees of compensation unless the shade of the subject's colour is mid-tone, or you want it to appear so. If you meter off a pale subject and you want it to remain paler than mid-tone,

you will have to select a *wider* aperture (or *slower* shutter speed) than that suggested by the meter. Just how much compensation to apply depends on how much lighter the subject is than mid-tone, something that can be determined by taking comparative readings from both. If you want to retain detail in this pale area, the most you can open up is 2 stops.

Another way to think about this metering method is as one of assigning tonal values. You decide on what in a scene *you* want to be mid-tone and let the other exposure values for different parts of the scene fall in around that. Using the camera's spotmeter, work around

## Larches

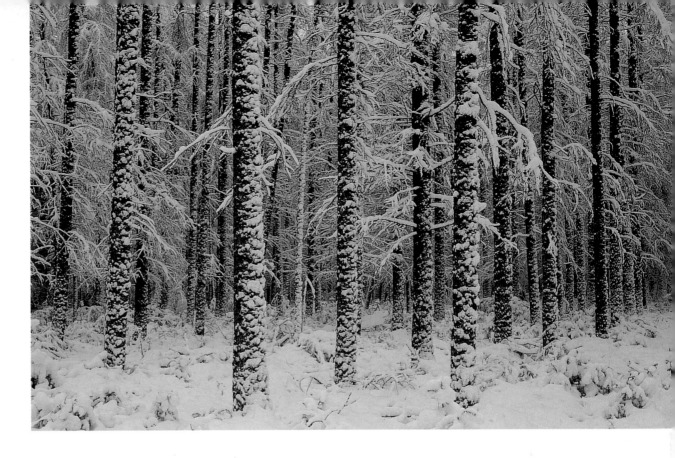

*The sky above was white, the snow at my feet was white, and the scene itself offered little in the way of mid-tones from which to read. There was also a marked tonal difference between the snow on the ground and that in the wood. I decided that the snow on the ground would be my lightest point, took a spot reading from it and opened the aperture until the meter registered 1²/₃ stops over-exposure, allowing detail to be just visible and no more.*

90MM, FUJI VELVIA

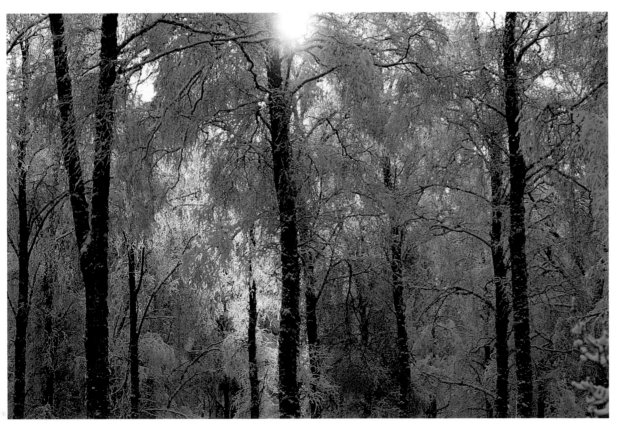

## Snowy birch forest

*Snow need not always be white. Indeed, in the shadows on this sunny day I had to make it mid-tone, to ensure that the brightly lit area was not burned out. The centre-weighted reading excluded the sun and most of the brilliant snow.*

90MM, FUJI VELVIA

**Abandoned timber harvester**

*The bright, overcast conditions made the snow more than 2 stops lighter than the shaded side of the machine, which I wanted to be well exposed. The high-key effect adds to the feeling of starkness, relieved only by the hard black line of conifers in the distance.*

20mm, Fuji Velvia

the scene, checking that your most important highlights will show detail and seeing which darker areas will become more obscure and by how much.

Your spotmeter will be useful again for the alternative metering method. Once you have identified and taken a reading from the mid-tone in a scene, you can use the spotmeter to find out which areas fall outside the 4 stop range of the film. If they are important (for example, detail in a snow-covered peak is important, clouds less so), you will have to apply compensation – this time in the opposite direction. So, if your spotmeter indicates that the snowy peak is actually 3 stops lighter

than mid-tone, you will need to under-expose your mid-tone by 1 stop – by selecting a *smaller* aperture – to bring the peak within the film's contrast range. This means, of course, that areas only 1 stop less than mid-tone will now become the darkest limits. I prefer to meter landscapes in this way. It is a convenient method for finding out if a graduated neutral density (ND) filter is needed to hold back the exposure value for the sky (see page 132), and if so what strength it should be. A sky 4 stops brighter than my foreground needs a – 2 stop ND filter, but if it is only 1¹/₂ stops brighter, none is needed at all as it falls within the recordable range.

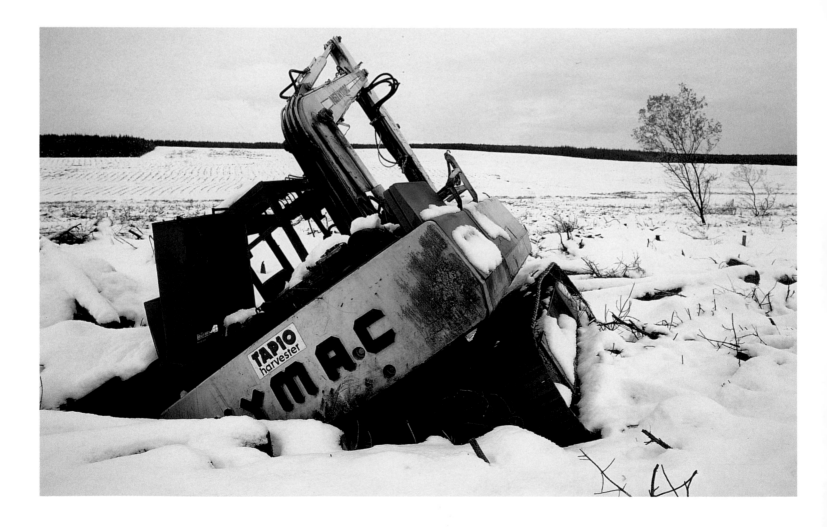

**Ash and waterfall spray**

*While the spotmeter gives very precise, focused readings, a contrasty scene can sometimes make it hard to know where to direct it. Here I opted instead for centre-weighted metering, selecting an area that included roughly equal amounts of the brilliant green foliage and dark background.*

180MM, FUJI VELVIA

**Black alder forest, Bialowieza, Poland**

*The arches formed by these alders created the point of interest; the panoramic format allowed attention to be focused on them without introducing too much of the surrounding forest.*

HASSELBLAD XPAN WITH 45MM, CENTRE-SPOT ND FILTER, FUJI VELVIA

# Orchestrating Space

Wild nature can be pretty scary. Although we are more insulated from it than in the past, there lingers a primal memory of its potency, manifest in a powerful need to order and control it. Composition is the way by which we guide a viewer through the photograph – and hold their attention. Before we begin to put the picture together, we have to decide whether the main subject should be separated from or integrated with its surroundings; normally in landscape work we are trying to incorporate many different elements, a task that becomes more complex as we take in a wider view.

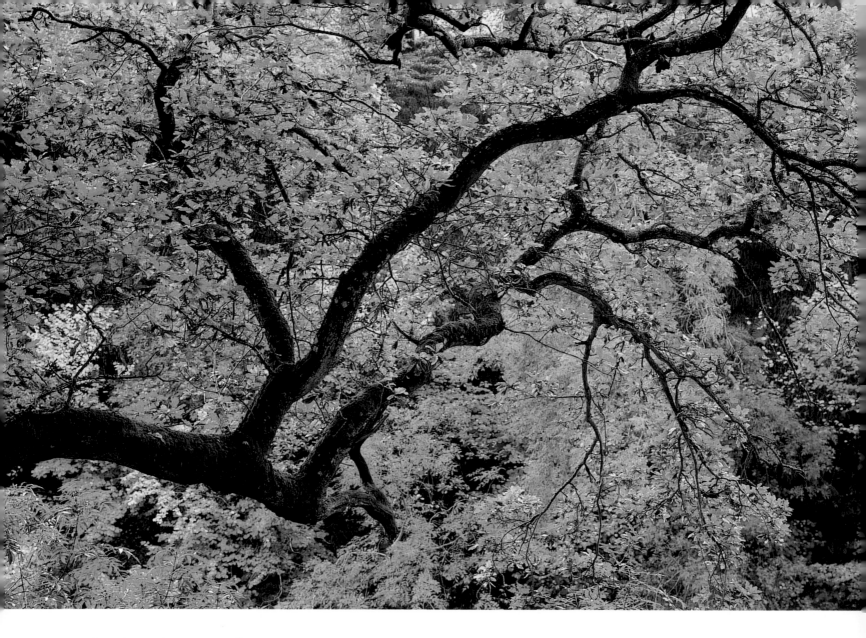

**Pedunculate oak**

*I framed this picture to exclude the straight-trunked tree from which this bough sprung across the gorge. A short telephoto lens provided enough compression to make the various branches appear on the same plane.*

90MM, FUJI VELVIA

## ELEMENTS OF COMPOSITION

Within the frame, whether it is the standard rectangle or an elongated panorama, there are certain points – the 'eyes' of a picture – that draw our attention. If the frame is divided into thirds, horizontally and vertically, the points where the dividing lines cross coincide with these 'eyes'. If you choose to be direct in your approach, for maximum impact ensure that the key element in the composition occupies one of these intersections. Bear in mind, though, that the 'rule-of-thirds' generally does

not work with symmetrical scenes, where an equal division feels more comfortable. Alternatively, you can tease the viewer by leaving the 'eye' blank and placing the subject nearby – the equivalent in speech to emphasizing the wrong word, which may irritate the listener but will help to keep their attention.

An intriguing and unusual characteristic of our visual system is an ability to make sense of and to see depth in a two-dimensional image – show a cat a picture of a growling dog on a long lead and it does not react. But the

process of translating our three-dimensional appreciation of the world into a flat image and preserving that sense of depth is tricky. Before I even pick up the camera, I share its view of the world by shutting one eye. The interest of a scene is sometimes no more than the depth that our sight invests in it – one reason why many landscape pictures fail to live up to the photographer's memory of the scene.

If one element of the composition is to be clearly delineated from the others, their presence should do nothing to distract from it. Even if the composition is an inclusive one, relevance to the story, or at least the pictorial integrity of the image, is paramount and anything that doesn't contribute to that should be removed or minimized. Edit now, because it will always be more trouble to do it later in the computer. In an inclusive image, the object is

to create a hierarchy of importance among the different components of the composition. As well as using familiar techniques, such as putting a wide-angle lens close to a foreground element to exaggerate it, we can employ juxtaposed advancing (red) and receding (blue) hues, shadow and highlight, converging lines and differential focus to give an impression of depth. The viewer's own aesthetic priorities can be challenged by giving unexpected prominence to one element over another, upsetting their sense of order by, for example, placing the main subject in shadow or using differential focus to give prominence to a less important element. The point of doing this is to encourage the viewer (or, if you prefer, the reader) of the picture to look at a familiar scene in a fresh way. A successful composition is one which, to paraphrase Samuel Johnson,

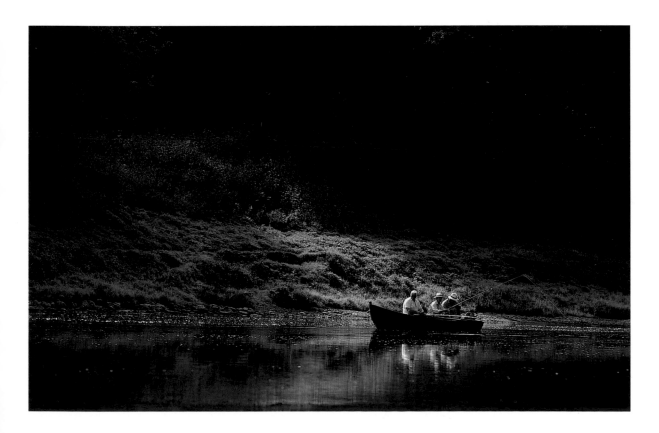

**Salmon fishers**

*A combination of light streaming through a riverside clearing and a position at one of the eyes of the picture ensures attention for the boat, even though it occupies only a small part of the frame.*

180MM, FUJI VELVIA

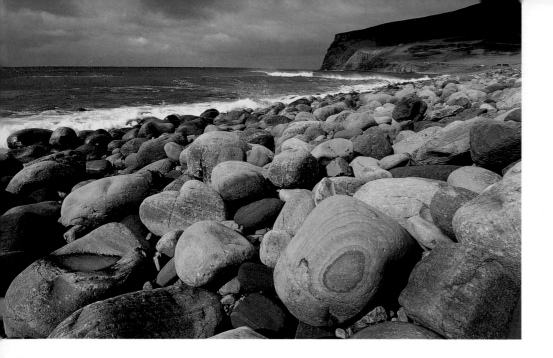

**Boulder beach**

*There is a strong bias to the right in this picture – both the patterned foreground rock and the cliff-line occupy that side. The alternative composition, which would have involved moving the patterned rock to where the one holding the pool of water is, would have brought the rock into conflict with the line of the waves. Sometimes you just can't win.*

20MM, −2 STOP HARD-STEP ND FILTER, FUJI VELVIA

'makes the familiar new and the new familiar'.

Perhaps this discussion of composition makes it sound like a mechanical process, which can be codified in the rule-of-thirds and practised through the application of formulas, whose function is to spoon-feed the content of the picture to the viewer. This is not so. Composition – arriving at a natural balance of description and scene-setting – is a deeply intuitive process and provokes the same sensation in the viewer as having listened to a well-crafted story.

A strong composition needs more than just depth. To hold the viewer's attention, it requires tension as well. Tension arises when contrasting colours, shapes, textures or forms come together. It also results when movement or thrust is contrasted with stillness or when elements in the composition block that movement. Our visual sense is stimulated by contrast. After the one-eyed check (for the two-dimensional qualities of a scene), I look for tension and work out if it can be used to emphasize the subject or to help hold the whole scene together. In this context, hill

slopes are more arresting than plateaux or cliffs (although it's best to avoid their appearance from the corner of the frame); a wavy strand-line is more interesting than a straight one; and smooth pebbles beside rough parent rock are more compelling than either on its own. Aesthetic discords can be used powerfully to echo real disharmony, too: the grimly straight, grey bulldozed track sits uncomfortably among the smooth curves of a heather-coloured moor.

## WHICH LENS?

Your choice of wide-angle or telephoto lens will affect not only the look of your composition but also how the viewer relates to its content. The German Romantic painter von Hardenberg wrote about the romance created by distance; in some of Ansel Adams' work we are distant onlookers – through his telephoto lens, rugged mountain ranges seem less intimidating. Perspective is compressed and, without modelling light, objects appear flat. Telephoto work makes the photographer more reliant on light and shade to create depth.

Used skilfully, the wide-angle takes the viewer into a scene, giving a real sense of being there. And with the distance between foreground and background exaggerated, depth is easy to portray. A low viewpoint adds to the picture's drawing power by providing a strong foreground element – crucial if the wide-angle approach is to work in non-panoramic formats.

Overall sharpness is usually most appropriate in these wide shots; as our eyes move from foreground to background, the image is clear, just as it would be if we looked at the scene ourselves. An out-of-focus background interrupts the illusion. As I describe on pages 129– 30, tilt/shift lenses allow us to achieve foreground-

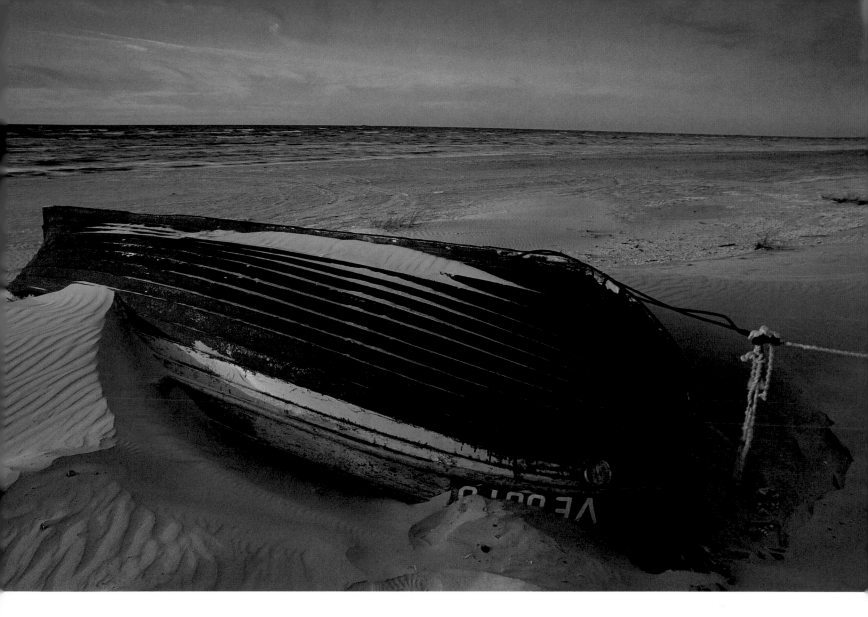

to-background sharpness without having to close down to the smallest apertures, but with ordinary lenses we can make best use of the depth of field at any given aperture by referring to the lens's hyperfocal scale. If you use a wide-angle zoom, the lens probably doesn't have one and it is worth thinking about buying a fixed focal length if you plan to do a lot of wide-angle work – or be prepared to do a lot of calculations. Here's why.

The foreground subject is just 1m away from my 28mm lens. To understand hyperfocal focusing, just keep in mind that, to all intents and purposes, depth of field extends equally in front of and behind a point of focus. If I focus directly on the subject, the hyperfocal markers indicate that at f16, the depth of field extends from about 0.68m to roughly 2.3m – so I can forget about foreground-to-background sharpness. If, instead, I move the focus so that the close point hyperfocal marker for f16 coincides with 1m (the lens is now focused at 2m), the other marker shows that infinity will be sharp, too. So, at the same aperture, I have achieved quite different focusing results by moving my zone of focus (the depth of field) so that the

**Abandoned boat, Kolka, Latvia**

*Here, using a wide-angle lens, I chose a viewpoint that not only kept the hull clear of the water but also provided a zigzag featuring the horizon, the edge of the sea and the keel of the boat. A more parallel arrangement is less engaging.*

20MM, FUJI VELVIA

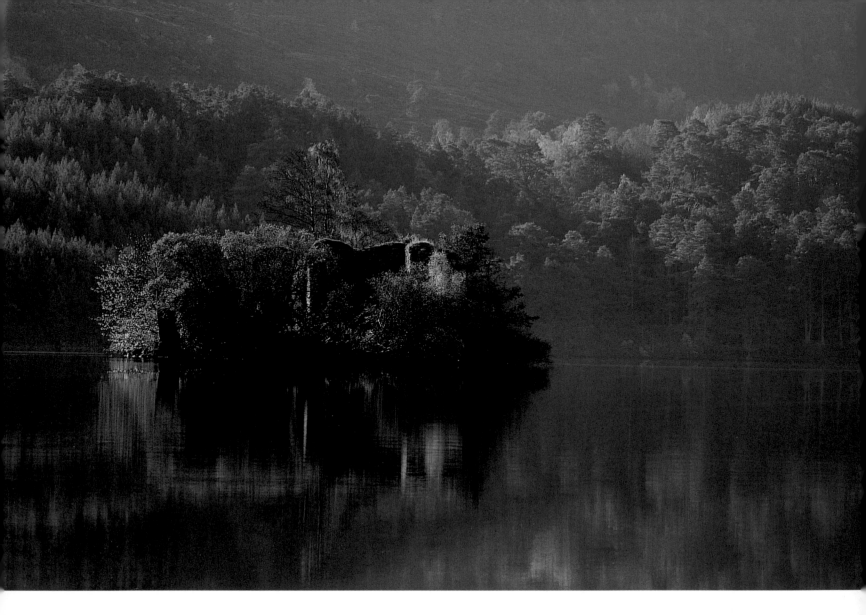

**Loch an Eilein Castle, Inverness-shire, Scotland**

*Reflections often lend themselves better to a symmetrical division of the frame than to one based on thirds. Here I have done both. The main concern was to ensure that the reflection of the tallest birch was not clipped by the edge of the frame.*

180MM, FUJI VELVIA

subject is at the edge of it rather than in the middle. Without a hyperfocal scale, you might perhaps be tempted simply to shoot at the smallest aperture and hope for the best. But even at f22, infinity is still not sharp, when the lens is focused on 1m. Moreover, thanks to diffraction (see pages 109-10), which increases as the aperture size decreases, resolution drops off sharply (you'll notice this especially around the edge of the picture) at very small apertures. I never stop down below f16 and prefer to use f11 and move back from my foreground slightly.

But how do we define 'sharp' in front of and behind the actual point of focus? When we focus light, we form two cones that are mirror images of each other, with their apexes touching at the point of focus on the film plane. In a defocused image, the point of focus is behind or in front of the film plane. The point of light no longer coincides with the meeting of the apexes, instead intersecting one or other of the cones. The point at which intersection occurs is termed the 'circle of confusion'. As long as the circle created by the spreading light doesn't exceed a certain diameter, the image appears

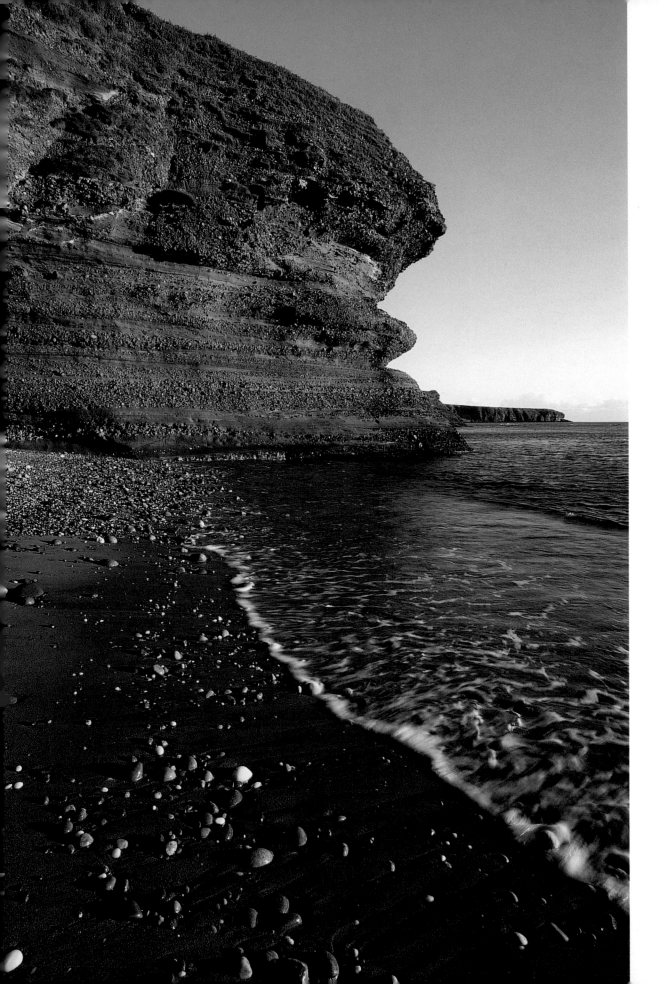

### Carlinheugh, Angus, Scotland

*Anxious to achieve foreground-to-background sharpness, I stopped down to f16 and set focus by reference to the lens's hyperfocal scale. The exposures I kept were the ones where the ribbon of surf didn't appear from the corner of the frame, but fell above or below it.*

20MM, FUJI VELVIA

sharp – it falls within acceptable limits, getting better towards the cone's apex. For 35mm photography, the maximum diameter of this circle varies depending upon the authority you heed and, since the circle of confusion is a crucial element in the equation to calculate hyperfocal distance, hyperfocal tables vary according to the diameter of the circle of confusion that is keyed in. Nevertheless, 0.03mm is widely accepted for this format. Another definition that can be applied is $^1/_{1,730}$ of the diagonal of the film gives the maximum acceptable diameter of the circle of a confusion; in 35mm this equates to 0.025mm.

If you want to be precise in setting the hyperfocal distance (and scales are not foolproof, as we are about to see), use this formula:

$$\text{hyperfocal distance} = \frac{\text{focal length of lens}^2}{\text{aperture} \times \text{circle of confusion}}$$

Apply this to the example I cited earlier:

$$\text{hyperfocal distance} = \frac{28 \times 28\text{mm}}{16 \times 0.03\text{mm}}$$

$$= \frac{784}{0.48}$$

$$= 1,633.33\text{mm}$$

$$= 1.63\text{m}$$

With the lens focused on 1.6m, its hyperfocal distance at that aperture (in the absence of a mark, you will just have to estimate), I know that depth of field will extend from half its distance – roughly 80cm – to infinity.

How does this work with panoramic formats? It is best to apply the 'diagonal divided by $^1/_{1,730}$' rule. On the Hasselblad Xpan, the diagonal is 69mm, which gives a circle of confusion limit of 0.04mm. With a 45mm lens set to f11, the hyperfocal distance comes out at 4.6m. That accords quite closely with the lens's scale. If we substitute the usual 35mm limit (tempting, since we are using 35mm film) of 0.03mm, we focus on something just past 6m which, according to the scale, is taking the far point of focus beyond infinity. Quite simply, larger formats mean larger circles of confusion, which are enlarged less in the final print. Start putting in figures for 6x6cm with the same focal length at the same aperture and you'll find the hyperfocal distance shortening. Don't

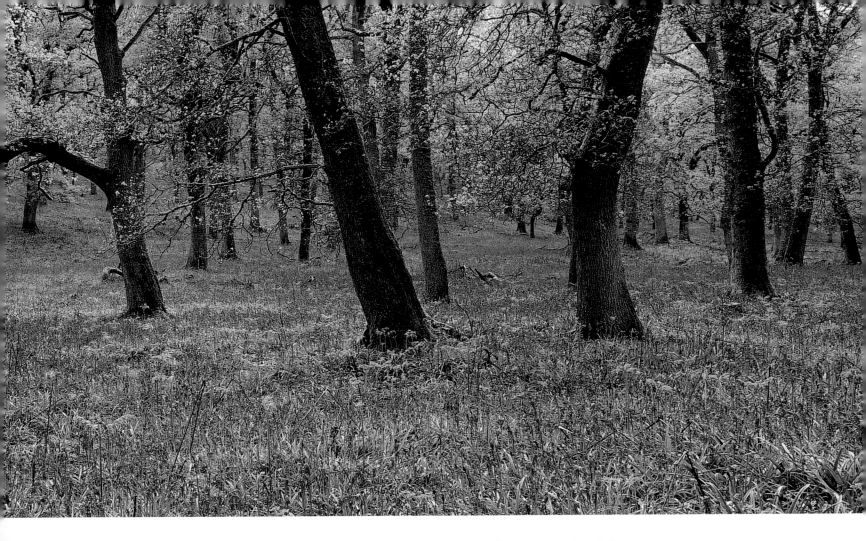

### Bluebells

*Although these two images feature the same compositional structure (look at the shape framed by the tree trunks), the 35mm version (LEFT) gives rather more prominence to the trees.*
*The panoramic shot (ABOVE), to my taste, strikes a happier balance, better depicting the expansiveness of the bluebells and allowing the viewer to see deeper into the wood.*

35MM VERSION: 90MM, FUJI VELVIA;
PANORAMIC VERSION: HASSELBLAD XPAN
WITH 45MM, CENTRE-SPOT ND FILTER,
FUJI VELVIA

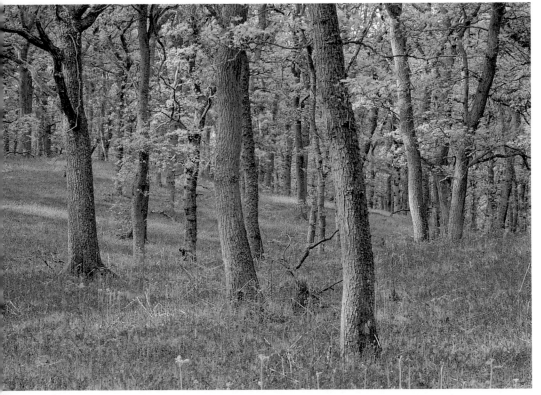

**Dogwood**

*This picture relies primarily on its colours to hold the viewer's attention. Other contrasts, between straight and forking, bare and budded, are of secondary interest to the scene's reds, enhanced by subtle backlighting.*

300MM + X1.4 CONVERTER, BEANBAG, EKTACHROME PANTHER 100X

zone of sharpness. It can be expressed in the formula:

$$\text{circle of confusion} = \frac{\text{focal length} \times (\text{magnification})}{(\text{aperture})}$$

Hence, with a 28mm lens where magnification is 0.1 (one-tenth life size on film – we're getting close to a toadstool here), shooting at f11, the circle of confusion of a point at infinity is 0.25mm in diameter, whereas with a 280mm it is 2.5mm. The background is unsharp in each, but more obviously so with the 280mm lens.

### COMPOSING IN THE PANORAMIC FORMAT

The panoramic format has enjoyed a boom in popularity in recent years, not least because of the introduction of true panoramic range finder cameras using 35mm film. The costs of running these 24x65mm cameras (in terms of film) and the price of the cameras themselves are relatively low compared to the traditional 6x17cm format. Typically, it costs about four times as much to produce each picture in the larger format although, of course, it withstands high magnification much better. Nevertheless, the greater portability, convenience and responsiveness of cameras such as the Hasselblad Xpan, matched with an image quality suitable for most uses, has made the 24x65mm format a firm favourite with many landscape photographers.

The popularity of the panoramic format may reflect the way it harmonizes with the way we look at things. In the absence of dominant vertical elements in the landscape, our eyes tend to scan from side to side, rather than up and down. It is easier to move our heads

be deceived: you do not get more depth of field with larger formats (quite the opposite, in fact – see page 125). What is happening is that the 45mm 'standard' lens on 35mm becomes a (very) wide-angle on 6x6cm; less magnification means greater depth of field.

But let us be clear here: wide-angles do not give the greater depth of field (compared with telephotos) that the received wisdom suggests. It is true that they embrace a larger section of background, but under most circumstances depth of field is purely a function of aperture and magnification ratio. As long as the size of the subject in the frame and the taking aperture is the same, the depth of field is unaltered by using a 28mm lens or a 280mm one (just so long as the same format is being used – see page 125).

The apparent shallow depth of field that arises with telephotos results from the magnification of circles of confusion beyond the

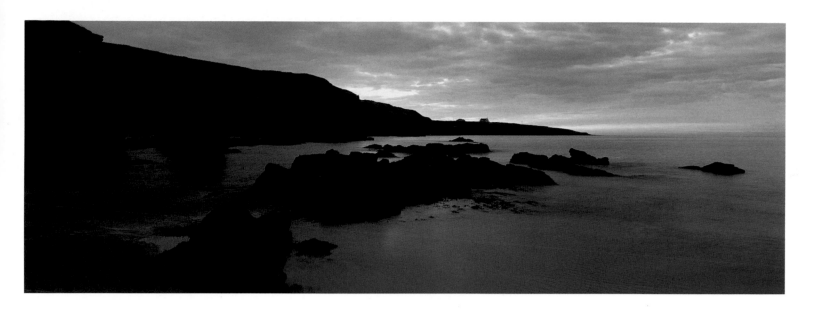

from side to side and our eyes are shaped to permit greater lateral movement. The wide view accords with this way of seeing more naturally than the standard, 'rectangular' format. In a wide-angle rectangular photograph with a prominent foreground the eye tends to fix on that area first, then travels up towards the horizon, and then the sky. Importantly, too, the whole scene in a rectangular picture can be taken in at a single glance, whereas a panorama triggers the scanning response, with implications for how we compose the image.

As we saw on page 33, relevance is the key to a successful composition, and if the photographer's job is to summarize a scene for the viewer's benefit, then the more concise that summary the better. In this respect, each format has its advantages and disadvantages. A 45mm lens on the 24x65mm format encompasses the same angle of view as a 25mm lens on the standard 35mm format. In order to 'get everything in', however, each element is effectively shrunk on the smaller format, and foreground and sky feature, too. These then have to be worked into the

compositional framework to justify their inclusion. The panoramic format, in contrast, presents the wide-angle view but without the big foreground and sky. Sometimes this is desirable, but sometimes the format's width introduces more information than is needed to tell the story.

Strong foreground elements in wide-angle compositions help to lead the viewer into the scene, but until recently this compositional device was effectively out of bounds to panoramic photographers. Now, wide-angle lenses are available for both 24x65mm and 6x17cm cameras. Making images with these lenses calls on the photographer both to scan and look from top to bottom of the frame, and the technique takes some practice to perfect. Compositions made with 'standard' lenses – 45mm on the 24x65mm and 90mm on the 6x17cm – are concerned mainly with the middle distance and beyond; what is lost in foreground interest must therefore be compensated for by the content of these areas.

As with the standard formats, there are particular zones in a picture where key elements

**The beginnings of a gloomy day**

*A high-contrast scene such as this may require exposure bracketing, something that becomes very expensive with the 6x17cm format, especially when lots of extra originals are required for stock. In contrast, the smaller 24x65mm format is very economical and its lightness allows the photographer to respond quickly to rapidly changing light.*

HASSELBLAD XPAN WITH 45MM, CENTRE-SPOT ND FILTER, FUJI VELVIA

of the composition should fall for maximum impact, as our eyes naturally gravitate towards these points. Making successful upright compositions in the panoramic format is, however, highly challenging, not least because scanning vertically (especially to the height of a panoramic picture), doesn't come naturally. The wide format offers challenges – and opportunities – of space unavailable in other formats, and just as a wide-angle 35mm picture can fail because of a weak foreground, so too the wide view fails when the space it offers isn't exploited to the full.

Yet empty space in a panoramic picture need not equate to dead space. Just as a skilful advocate pauses to add emphasis, so the photographer can deploy the space around the subject to highlight its importance. Crucially, however, this space should be kept free of alternative interest or distraction; it is there merely as a foil to the subject – or to provide a rest for the eye. In cultures that read from left to right, space on the left side of the subject tends to be more emphatic than space on the right, because our eyes are moving across the picture from that direction.

There is no doubt that certain types of landscape lend themselves more readily to the wide view than others – the format just seems made for distant mountains and their reflections, for example. As the format is popularized, we are likely to see the emergence of novel themes as photographers, no longer hampered by the expense and inconvenience of 6x17cm, explore new fields. By virtue of its wide embrace, the panoramic camera is especially suited to illustrating themes of connection within the natural world and between people and their environment in a way that is hard to match in other formats. These themes

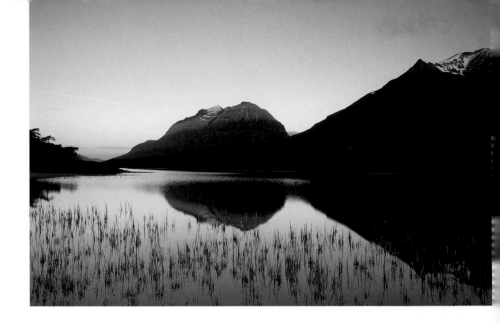

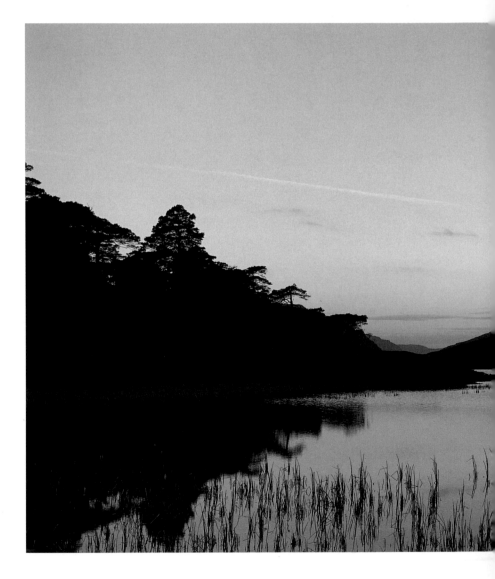

**Liathach and Beinn Eighe, Wester Ross, Scotland**

*Although the angle of view in these two pictures is similar, the inclusion of large areas of featureless sky and repetitive foreground diminishes the impact of the hills in the 35mm version (LEFT). The 24x65mm alternative (BELOW) minimizes these elements, with just enough foreground to create some depth.*

35MM VERSION: 28MM LENS WITH −2 STOP HARD-STEP ND FILTER FUJI VELVIA; 24x65MM VERSION: HASSELBALD XPAN WITH 45MM, CENTRE-SPOT ND FILTER, FUJI VELVIA

and the concept of complexity are explored more fully in Chapter 9.

Although sharing with the rectangular format, basic compositional concerns of harmony and discord, separation and inclusion, the panoramic format calls for a different, perhaps more intuitive, way of viewing the landscape. Some disparage the wide view as modish, just another quest for a different angle on the same old places. But the panorama has been around for a long time – since at least Classical Greek times if we regard their frescos as panoramas. There was a surge of interest in the eighteenth century, when the particular qualities of 360 degree panoramas were appreciated by many in the art establishment; Sir Joshua Reynolds was moved to comment that, '. . . nature [can be represented] in a manner far superior to the limited scale of pictures in general.' Whatever the truth of this statement, any device that causes us to re-examine the familiar is clearly a force for creativity.

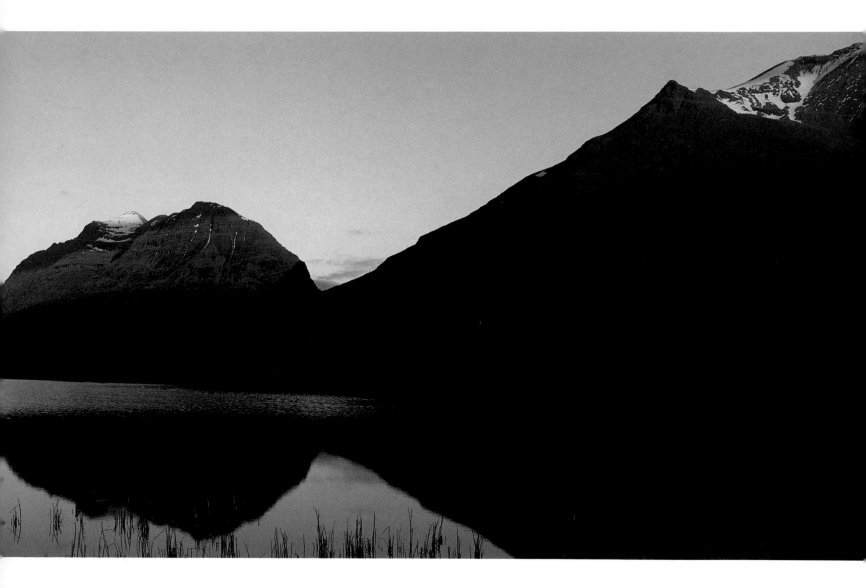

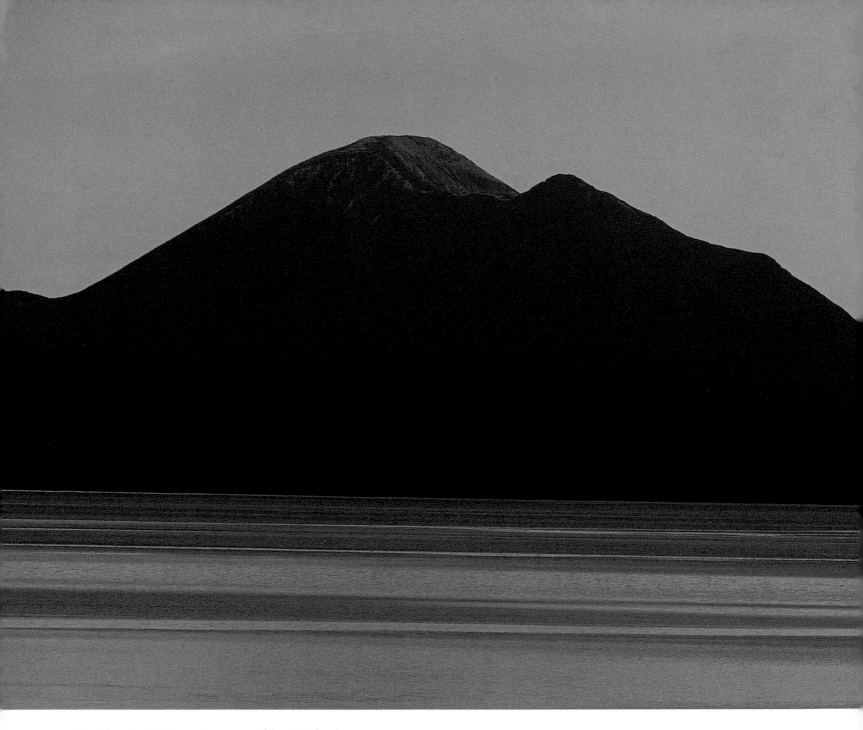

**Skye from Loch Carron, Inverness-shire, Scotland**

*The recent passage of a cold front had left clear cold air in its wake, ideal for photographing the distant mountains in the west. The low temperature also meant reduced evaporation from the sea loch, further improving clarity.*

300MM + X1.4 CONVERTER, BEANBAG, FUJI VELVIA

# The Power of Light

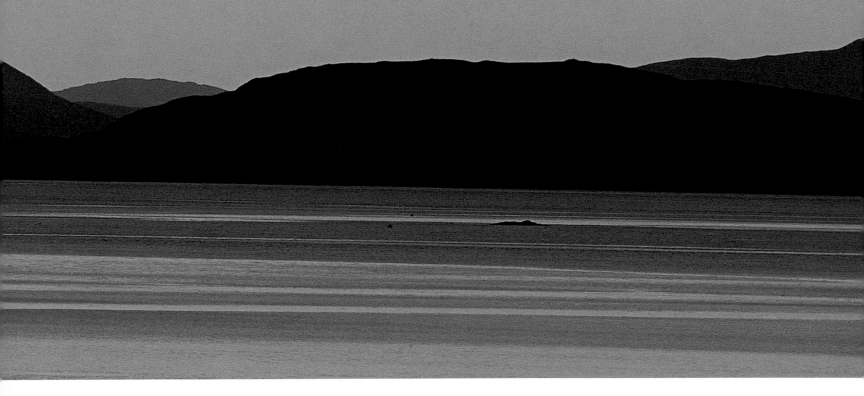

Some years ago, I spent nine days in an ancient campervan touring the north of Scotland. It was November, the days were short and the nights achingly cold, not least because of my van's informal ventilation arrangements. During the whole trip I enjoyed a total of just 30 minutes of good light – but what light it was! Most of the time a tight lid of cloud sealed the moist landscape, but now and again the sun prised it up, gilding the scene with extraordinary light. The low cloud base intensified the effect by reflecting the sunlight back down to sombre moors and pallid beaches. Today, the long, empty grey hours are forgotten and the trip is remembered only for its light.

**Torrisdale Bay, Sutherland, Scotland**

*Squalls of rain and hail were dashing in off the Atlantic, agitating the waves and blackening the sky. Every so often, however, the sun flooded the beach.*

20MM, −2 STOP HARD-STEP ND FILTER, FUJI VELVIA

A LANDSCAPE photographer's work for the day can be completed in 10 minutes – for of all the transforming forces (life, light, precipitation and colour – see *The Art of Nature Photography*, Chapter 10), it is light that most elevates the ordinary landscape photograph into something special. Marginal lighting appeals directly to our natural fascination with 'the edge', and almost without exception the most compelling images of the natural world take the viewer there. The edge is where contrasts arise and change occurs – from day to night, autumn to winter, living to dead, known to mysterious, land to ocean, ocean to sky. It is removed from the everyday, the ordinary, the usual. The edge is where we discover our limits, where, consciously or otherwise, we are drawn by our innate curiosity. The photographer who

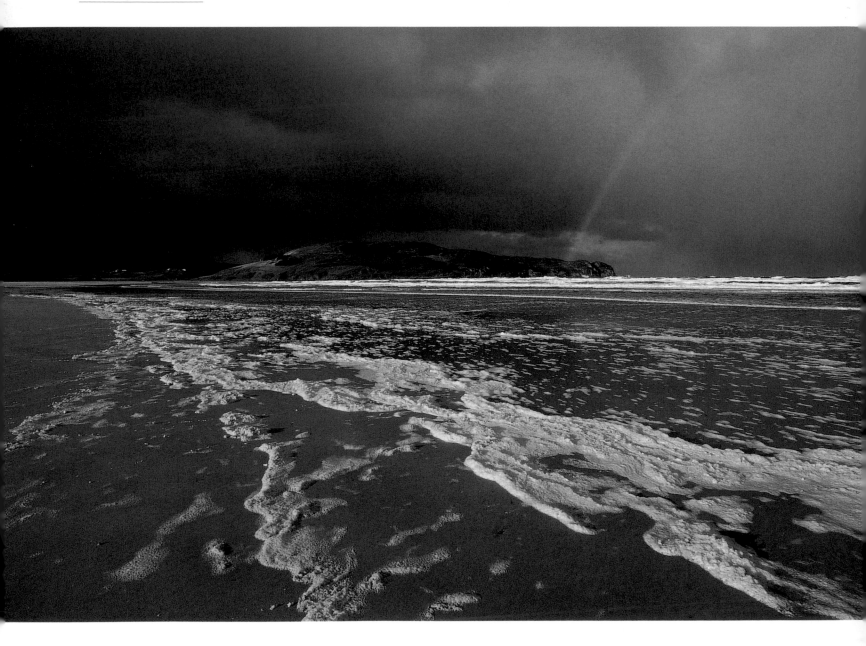

recognizes this human characteristic and takes pictures that connect with it is guaranteed the viewer's attention.

There is nothing we can do about the weather – and sometimes we may have to wait nine days for 30 minutes of good light – but an ability to interpret conditions as they develop may help us to anticipate the spectacular. Things happen quickly at the edge.

Photographers working at the more extreme latitudes – geographical edges – enjoy a real advantage in respect of the quality of light they have to work with. Nearer the equator, the sun rises and sets very quickly, as its rays strike the earth in a more perpendicular fashion. In higher latitudes, however, the rays fall more obliquely so that in high summer, when the earth's northern hemisphere is tilted towards the sun, anywhere north of 66.5

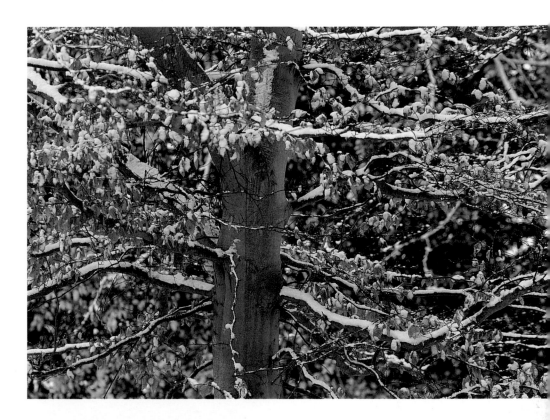

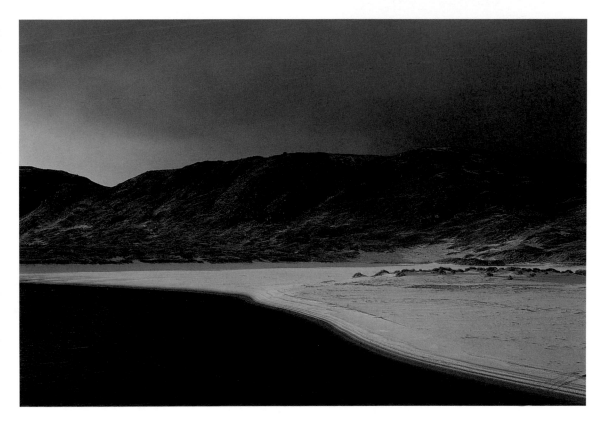

(ABOVE) **Snow on beech tree**
*Flat, shadowless lighting is ideal for showing details in the intimate landscape. If it is too dull, though, colours become murky, but when it is reflected from snow the picture acquires an attractive luminance and downward-facing shadows are lightened.*

MF 90MM, FUJI VELVIA

(LEFT) **River Naver, Sutherland, Scotland**

*A vicious north wind was driving a succession of hail storms into the river mouth, whitening the beach as it did so. Intermittent bursts of sunshine lightened the dark mood of the scene.*

MF 90MM, FUJI VELVIA

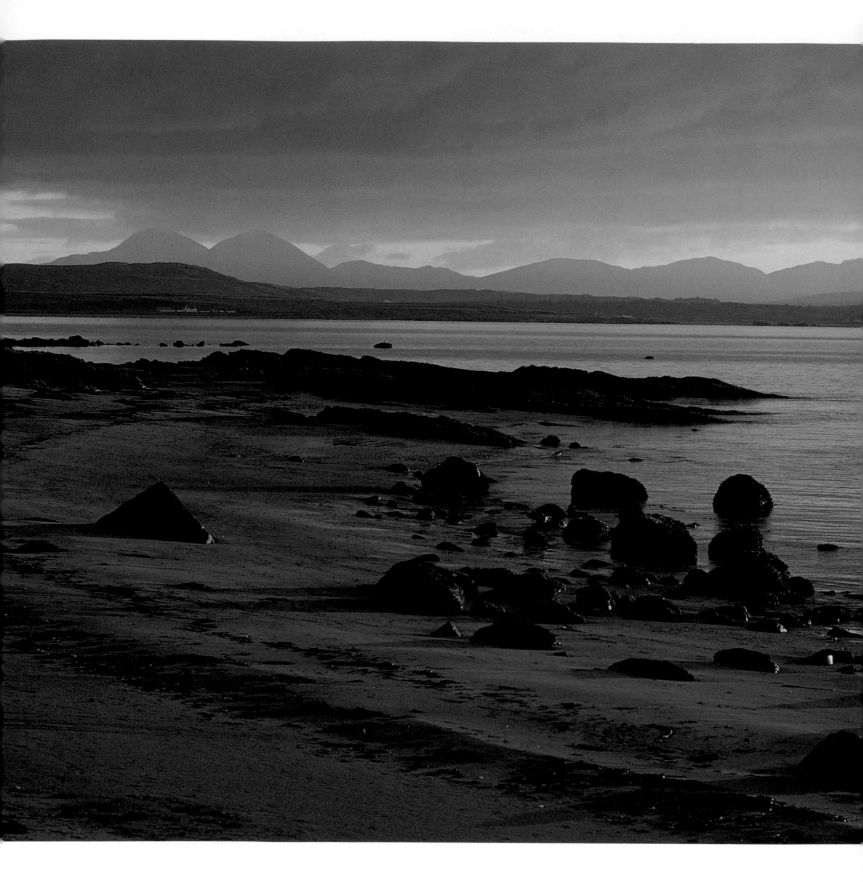

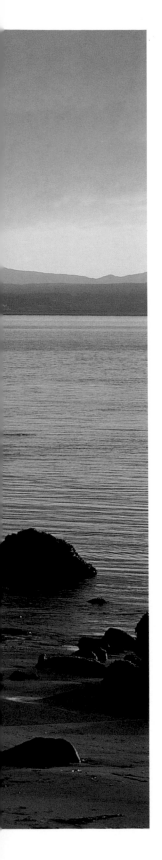

degrees (the Arctic Circle) receives the 24-hour attention of the sun. It is no coincidence, then, that we see relatively few pictures depicting dramatic light from the tropics compared to those from the Arctic and its periphery. There, the moment lasts longer.

### SOME LIGHT PHYSICS

When a particular type of atom, called a photon, moves, the energy released produces light. Photons move at different frequencies in a linear wave, and different wavelengths produce different colours of light. Those generating the least energy produce the longest wavelengths (if you think of shaking a skipping rope, it needs more effort to make shorter waves in it) and occupy the red end of the visible part of the electromagnetic spectrum. Short wavelengths – blues and violets – are at the opposite end.

The colour of light that so preoccupies landscape photographers results from the scattering of the different wavelengths by molecules of water, gas and dust in the atmosphere. Short-wavelength photons are readily

absorbed by these molecules, then scattered in different directions to give a blue sky. This phenomenon, known as Tyndall scattering, is visible because the photons are set against a black background – outer space. The purity of that blue diminishes when there is a large particulate load high in the atmosphere – such as from pollution or volcanic ash – because more of the longer wavelength photons are scattered too, diluting the blue with green and

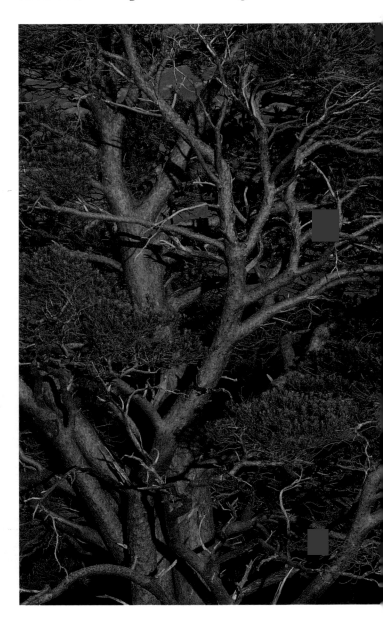

#### (LEFT) **Islay, Argyll, Scotland**

*An unpromising scene was completely transformed in minutes as the sun edged above the mountains on Jura, to reflect off the low cloud base and wash over Loch Indaal. 35mm's speed of operation is especially appreciated at times like this, when the light is so fleeting.*

MF 90MM, FUJI VELVIA

#### (RIGHT) **Pine boughs**

*Beautiful light isn't restricted only to the winter months – it is just that in summer you have to wait longer for it and, in middle latitudes, it is more transient. In this case, I had 2 minutes to shoot the blood-red light before it faded.*

MF 90MM, FUJI VELVIA

yellow. If we are after clear blue skies, regions well away from sources of air pollution hold the best prospects, and those at high altitude, where the particulate load is minimal and the cooler air is able to hold less water vapour, are even better.

The photographer working in the far north or south enjoys the full benefit of the earth's angle to the sun. An oblique passage of photons through the atmosphere (sunlight falls more perpendicularly the closer we get to the equator) sees the blue wavelengths absorbed and scattered first, then all the others through the spectrum until, at either end of the day when the sun is at its lowest angle, only the longest wavelengths remain to be scattered. The effect is especially pronounced in mountains, where their elevation exposes them to the most oblique – and therefore reddest – rays of sunlight.

The amount of particulate matter present in the atmosphere – whether natural or of human origin – also has a significant effect on colour. Following the eruption of Mount Pinatubo in the Philippines in 1991, the 20 million tonne load of ash generated dramatic sunsets around the world for some time afterwards, until the larger airborne particles dispersed. In general, improved dispersal of photons at the red end of the spectrum equates to better sky colours. It is ironic to reflect that had colour photography existed before the Industrial Revolution, its practitioners would have witnessed fewer intense sunsets than we, thanks to our polluting ways, see today.

While early morning light can be spectacular, if you are after the most vivid sky colours, wait for sunset. If the dawn air is damp as a result of overnight cooling, its dust load (through the effects of gravity) is smaller than in the drier air of evening, diminishing its capacity to scatter red wavelengths.

At sunrise and sunset, then, we have a choice: we shoot with the sun, so that it provides front or side illumination for our subject (just watch your shadow), or we can face into it, for silhouettes and maximum sky colour. If you want to shoot into the light, a sunrise or sunset without clouds can be a disappoint-

**Montrose Basin, Angus, Scotland**

*In the time it took the tide to fall a few centimetres, the colours in the lagoon shifted from yellow (*BELOW LEFT*) to orange (*BELOW RIGHT*). I prefer to shoot some frames before the sun reaches the horizon, so that I have more colour options and as a fallback in case the sun is blocked by clouds on the horizon.*

300MM + X1.4 CONVERTER, BEANBAG, FUJI SENSIA 100

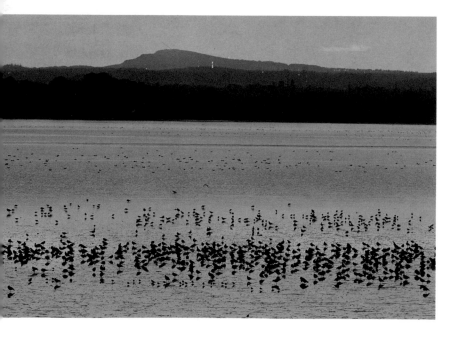
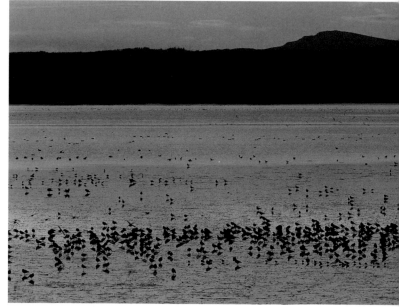

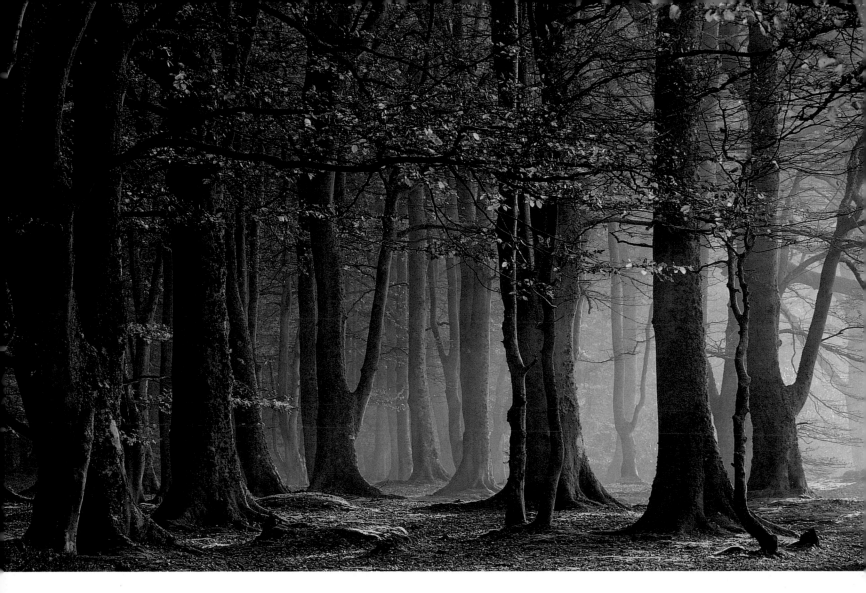

ment. Clouds in the west reflect the colours of the setting sun long after it is too low to illuminate the landscape. Clouds are important, too, if we are shooting with the light: if dark enough, they appear to intensify the red light of dawn and dusk by setting up contrast.

The light changes so quickly at the edges of the day that we have to be ready and waiting for it. Knowing where the sun will rise and set is important in deciding locations ahead of time. In temperate latitudes, the difference between where the sun sets in summer and winter may be as much as the distance it travels to the north, (or south if you are in the southern hemi-sphere) in six hours. Unfortunately, a neat 15 degrees per hour rule does not apply, firstly since the earth's equator is tilted relative to the plane of its orbit around the sun, and secondly because the earth describes an ellipse rather than a circle during its orbit. These effects combine in the Equation of Time.

During most of the year, a compass will give only an approximation of the sun's position at a given time. Sometimes that is enough, but if you need to know whether the sun will peek around the edge of a mountain just before sunset, a more precise approach is called for. The algorithms involved in the equation of time are

**Beech wood**

*By the time the beeches colour up in mid-autumn, the sun scarcely reaches round to light this woodland. In some years, there are no more than two or three days when peak colours coincide with overnight rainfall (for the richest colours), good light and calm conditions: in others, there are none at all!*

180MM, FUJI VELVIA

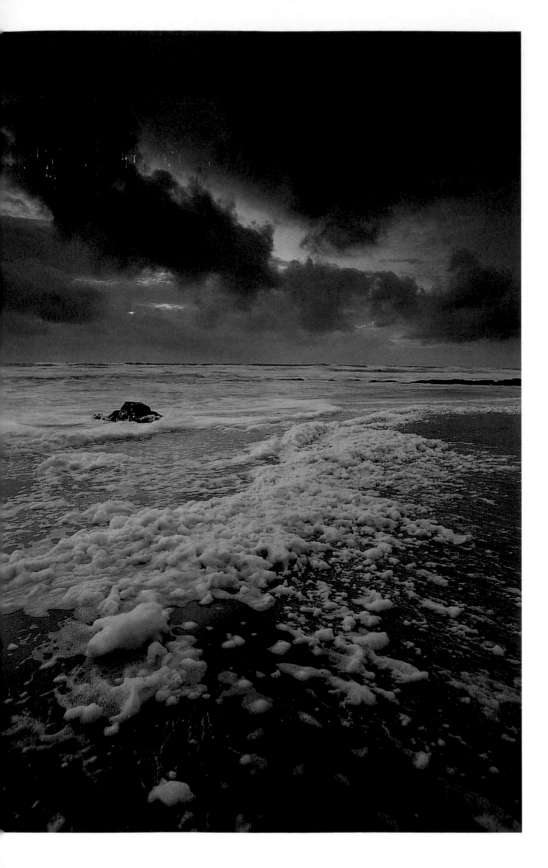

complex for the non-mathematician and the simplest solution is to log on to a dedicated website such as: www.susdesign.com/sunangle/ An ingenious shareware programme by Christopher Gronbeck allows you to input your latitude, then calculates the actual position of the sun on any day of the year and any time of the day at that location, as well as its altitude. Simply obtain the data ahead of time and take a printout into the field, or access the Internet on location to access the information.

The challenge is heightened at some locations, especially those with a northerly aspect (in the northern hemisphere) when the sun reaches round into them for only a few days or weeks of the year; bad weather then means a long wait for another chance.

The interest of dramatic skies can be increased by including a suitable foreground. Wet surfaces provide an ideal counterpoint to the sky, relieving a black void in the lower part of the picture. Maximize the size of this feature by getting in close and low to it, and beware of overlapping the reflected object – perhaps a mountain – with the edge of the reflective surface; complete reflections usually look best. Determining exposure is as simple as deciding which part of the sky you want to represent the

### Islay, Argyll, Scotland

*The waves that ram into Saligo Bay on Islay's west coast have a fetch the width of the Atlantic Ocean. In stormy weather, local conditions create masses of spume, in places accumulating to a metre or so in depth. Low light levels and a buffeting gale-force wind required the tripod, set as low as the desired composition would allow, to be ballasted with my camera bag. An exposure of $^1/_2$ second was needed, rather less than that required on a bigger format if I wanted to achieve the same depth of field.*

20MM, −2 STOP HARD-STEP ND FILTER, FUJI VELVIA

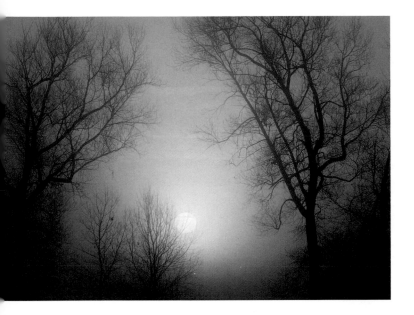

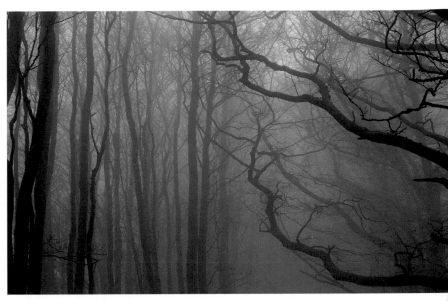

mid-tone and letting the rest fall into place around that (see pages 25–8). Normally, sunset reflections show a greater contrast range between foreground and background than slide film can render, and a – 2 or even – 3 stop graduated ND filter is required (see pages 28 and 132). Snow-covered peaks, however, can be so bright even in reflection that a graduated ND has the effect of making the reflection look brighter than the hill itself; in this instance, only a 1 stop graduated ND is needed.

If you are keen to link the edge between land and sky with a silhouette, look for an evenly toned section of the sky, as even small clouds interrupting the outline of a silhouette can confuse its identity. The afterglow that sometimes follows sunset is often the best time for rich colours and clear skies.

## Fog

As I describe on page 58, red wavelengths of light have particular physiological effects on our sensory system, making these hues especially attractive to us. Water, however, is inefficient at absorbing these long wavelengths, whereas the short blue ones are readily scattered (accounting for the blue look of underwater photographs taken without flash). But while the cool blues associated with fog may not be as arresting as a red sunset, the simplicity fog brings to compositions can be appealing in its own right. The phenomenon may be short lived, so it is useful to recognize the conditions that bring it about.

Fog most commonly results from the condensation that forms when a surface warmed during the day cools at night. The cool nights that can follow a warm autumn day give rise to the conditions for radiation fog formation, so long as the sky remains clear. If cloud cover creeps in after fog has formed overnight it will prevent the sun from warming the ground, slowing the dispersal of fog in the morning. The most attractive conditions develop as the sun begins to penetrate the fog. Not only do the colours in the picture become warm, but when sunlight is forced through a small gap – such as between the needles of a pine tree – the pin-

(ABOVE) **Beech wood in fog**

*While fog may deprive a scene of its colours, if it is not too thick it can create a sense of depth.*

180MM, FUJI SENSIA 100

(ABOVE LEFT) **Willows**

*By chance, I was driving past these willows near home when the thick fog began to clear. With a little manoeuvring, I positioned myself so that the sun would appear to be cradled by the two largest trees. The fog was still sufficiently thick to prevent flare, but not so thick as to rob the scene of its warmth.*

180MM, 81A WARM-UP FILTER, FUJI SENSIA 100

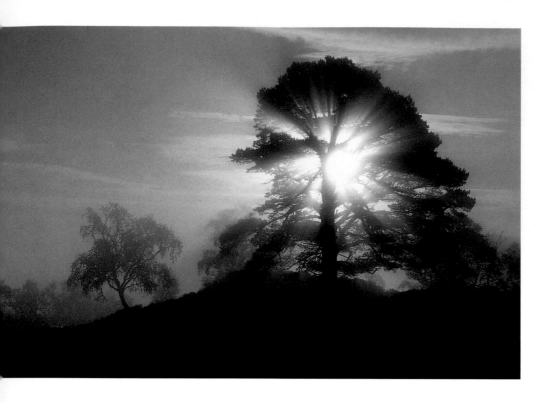

**Pine and birch wood**

*Tree trunks are useful for concealing a bright sun, although you will need to move your position frequently. Fog reveals the rays of light filtered by tree branches, helping to relieve dark areas of the composition.*

55mm, Fuji Velvia

points of light spread out dramatically as rays.

Another type of fog seen commonly in coastal areas and valleys is advection fog. It, too, results from condensation, but this time from moist air meeting a cool landmass or cool air moving downslope overnight into a warmer or humid valley below. Getting above these fogs (even haar – sea fog – is rarely more than 300m/1,000ft deep) offers the exciting possibility of picturing landforms rising up through the clouds.

## Frost

Frost embodies coolness more completely than fog; not only does its colour palette occupy the blue end of the spectrum (when it reflects the clear sky that gave rise to it), but its forms are angular and its physical effects uncomfortable. Yet while most of the associations with frost are negative, hoar frost lures photographers with its intricacy in close-up

and capacity to render pastel hues in the wider landscape. Frost is crucial, too, in the development of autumn colours. Areas with a Continental-type climate generally experience low temperatures earlier in the autumn than those ameliorated by the influence of the ocean, so that woods in central areas of a landmass tend to produce more spectacular shows than those nearer the coast.

Like fog, frost arises when heat is radiated from the ground on a clear night. For hoar frost to appear, humid air near ground level must drop to below 0°C (32°F) and crystallize without first condensing into dew.

When the frost is light, you will notice that, within a small area, some places are more prone to experience hoar frost formation than others. Those exposed to greater air flow or turbulence, and which are therefore less humid, are unlikely to see frost formation. Similarly, deeply shaded places which have been prevented from heating during the hours of daylight are also less promising.

### A word about rainbows

Of the various optical effects resulting from the diffraction of light by water droplets or ice crystals, rainbows are the most frequently encountered in middle and high latitudes, although they are less common in the tropics. And while we can wait at a particular place for clouds to colour up at sunset, a rainbow is too ephemeral to allow such an approach.

Rainbows appear when the sun is behind the photographer and the shower of rain in front; they cannot appear over a backlit landscape. The most vivid rainbows occur when the size of the water droplets is about 4mm (1/6in) – a large raindrop; the spray from a waterfall tends to produce rather weak colours. Sunlight

refracts from the edge of the water droplet, then that energy is reflected off the back of the droplet. Each wavelength reflects at a slightly different angle, but since all the drops of rain reflect the light at the same angle, coloured bands form. Red, the longest wavelength, appears at the top of the rainbow, reflecting at 42°, the others then reflecting at progressively shallower angles. Should the sun rise higher than that in the sky, the rainbow will disappear. Towards sunset, a colour shift towards red takes place and the rainbow will be at its broadest.

A rainbow is composed of about 95 per cent polarized light, so it follows that a polarizer will get rid of most of the light reflected (at a favourable angle) from the water droplets. It will, however, 'purify' the rest. Nevertheless, it is also quite possible to make a rainbow disappear altogether and a mild (−1 stop) graduated ND filter is usually a better way to enrich colour.

## LOOKING AT THE LARGER WEATHER PICTURE

The west coast of Scotland, my home country, is often maligned for its inclement weather; mountain ranges greet moist air masses moving in off the Atlantic and, by urging the clouds upwards, cause them to shed their loads on disenchanted visitors and inured residents alike. Some areas receive up to 1.2m (47in) of rain a year, whereas in parts of the east, in the shadow of the Grampian mountains, rainfall is more in the order of 0.75m (30in). So, on the face of it, the east would seem to be a safer bet for reliable photographic weather. As we have seen, however, landscape photography often relies on clouds to fill space and reflect colour. The weather systems bringing rain to coastal areas facing the prevailing wind are often

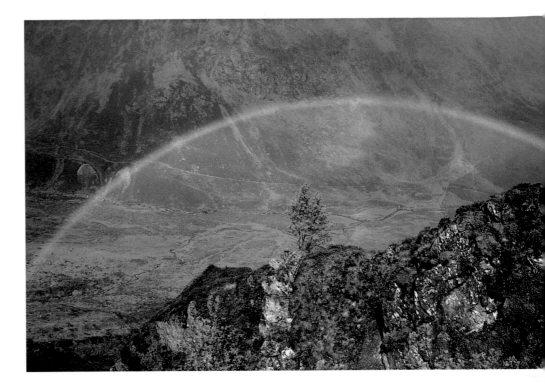

short lived as they move through, producing a mix of weather more conducive to atmospheric photography than cloudless blue skies.

The movement and interaction of warm and cold air masses are responsible for weather. Reading the clouds can help us to anticipate the weather ahead by revealing the approach of fronts – the leading edge of these air masses. The appearance of high-level clouds, wispy cirrus or altocumulus, may foretell the arrival of a warm front, as warm air gradually rises over a cool air mass. If middle- and lower-level clouds quickly follow, widespread (though short-lived) rainfall is likely. When a cold front encounters a warm air mass, it forces it up rapidly by convection, building towering cumulus clouds and lowering air pressure. This in turn increases wind strength as air moves in to fill the low-pressure area, and heavy rain, often localized, can be expected. If atmospheric conditions are conducive, the cloud may

**Rainbow and rowan**

*While I was on a search for arctic-alpine plants, a passing shower swept down the other side of the valley just as the sun lit a rowan tree below me. The knowledge of the image's authenticity (it is just too obvious to make up in the computer) goes some way to compensating for the relatively weak colours of the rainbow.*

135MM, KODACHROME 64

**Bell heather**

*While low-angled evening light might be perfect for providing shadow relief* (ABOVE RIGHT), *sometimes colour rendition suffers. Bell heather seems almost to glow in semi-shade, and the subdued sunlight in the picture on the left produced a more accurate record of the colour I perceived.*

55MM, FUJI VELVIA

mature into a cumulonimbus incus – a thunder head – with violent weather to follow. A dream sequence for photographers involves the passage of a cold front with its clear air (cool air can hold less water vapour than warm) just before sunset, when the brilliant light contrasts sharply with the gloomy skies of the warm air mass now being forced upwards by the cold one.

## CONSCIOUS COLOUR

Just as the painters of the Romantic period delighted in the conscious use of colour, so too have we seen colour evolve into a theme in its own right in landscape photography. We remain hampered, however, by the fact that in the physiological process of object recognition we look first at an object's outline. Colour is then assigned to the object, partly as a result of retinal stimulation but also by our memory. It takes a conscious effort then to suppress the 'shapes' response and instead look at the landscape in terms of the colours that fill it and how they work together. It is all too easy to

allow colour to become an incidental theme in a photograph.

While film is capable of reproducing pretty much the whole gamut of colours we see, its performance in respect of contrasts is very poor, leading to a large gulf between memory and record. Furthermore, our understanding of a subject's colour is as much learned as perceived; if we view a familiar object under a fluorescent light, its colour appears almost unchanged when it is moved into daylight or set in front of a tungsten light source. This is not so with film, where it will acquire a green or orange cast under artificial sources, appearing neutral only in daylight. But the colour temperature of daylight varies widely, too, depending on time of day, the colour of reflective surfaces and the effects of shade. If I were to view the same object in the shadows on a blue-sky day with lots of snow on the ground, it would acquire a marked blue cast, something my brain filters out. Other optical effects, such as those of adjacent colours on each other, further complicate issues of colour accuracy.

'Correct' colour in landscape photography, then, is elusive, and indeed the unperceived colours rendered by film are sometimes what makes a photograph eye-catching in the first place. The introduction of Fuji Velvia in 1990 set the new standard not only for sharpness in E-6 films but also for colour saturation (how far a hue is removed from grey). Some photographers find its colour palette, especially the greens, over-enthusiastic, but its use is now so ubiquitous that it has moulded our expectations of how colour should appear in photographs. It is particularly responsive in marginal lighting conditions, saturating even weak sunsets and sunrises, and has a naturally attractive warm bias. Rather like eating tomato

**Sun over larch and Scots pines**

*An overnight stay in a hide to watch for capercaillie yielded no pictures but the sun appeared once the birds had dispersed at 8am.*

300MM, KODACHROME 64

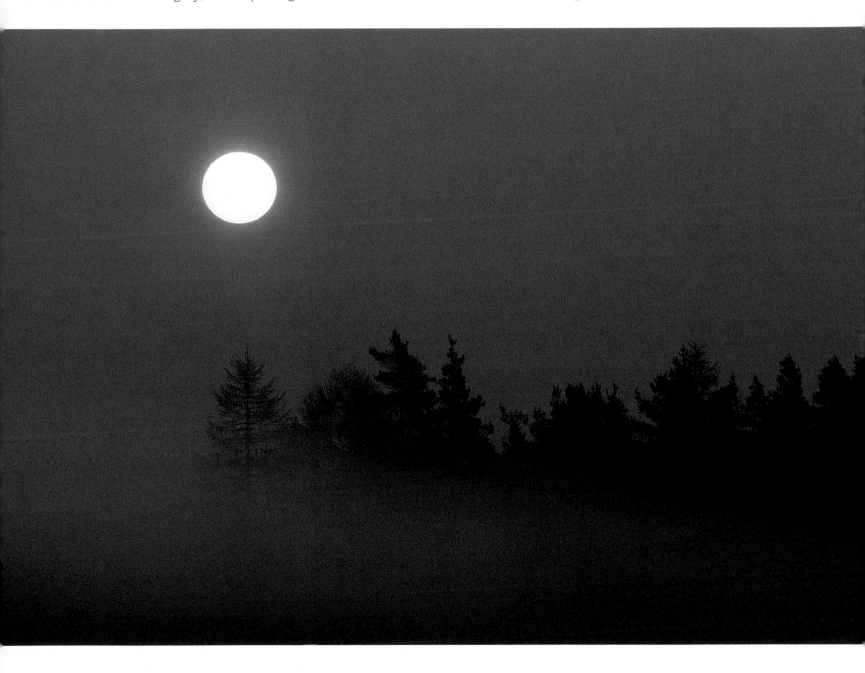

ketchup with everything, however, it does tend to dull our appreciation of subtlety, and so the more restrained palette of Fuji Astia (designed mainly for studio work, where colour accuracy is an important concern) has a following among some outdoor photographers.

## MAKING COLOUR WORK

Colour affects the photographer and the viewer on both a physical and an emotional level. Red wavelengths have a natural point of focus beyond the retina, requiring the eye to refocus. This gives the sensation of red as advancing: it excites our senses. Green is regarded as a restful colour, in part because its wavelengths do not require to be refocused. Blue, on the other hand, seems to recede. Set red and blue of the same saturation and lightness together and they appear to flicker; as a device for catching the viewer's eye, this is hard to beat – and it also works with red and green, and cyan and orange.

The key to successful colour use lies in arranging contrasts. In landscape work, where we can exert no control over the colour of the elements in a scene, we must actively seek colour and use light to strengthen a contrast. For example, if I am shooting in a snowy location on a sunny day, I will want to make best use of the blue sky and blue snow shadows by seeking subjects with strong, warm hues. The best contrasts appear when complementary colours are juxtaposed. Complements are colours that, when mixed in their light (rather than pigment) form, make white light: red and cyan; blue and yellow; magenta and green. Placed side by side in equal quantities, each enhances the effect of the other, making the whole scene appear more vivid. In training our colour response, we need not only to switch on to the colour of particular objects, but also to imagine possible contrasts that could arise if the light were different. The yellow aspen may look all right today against the steely sky, but how much better it will be tomorrow after the front has passed through, leaving a clear blue one in its wake. The patch of green bracken scattered through the glowing bell heather might look fine in the bright sunshine today, but the colours will be more pronounced once soaked by rain and polarized (see pages 133–4), especially if the sun is diffused.

Consider, too, the use of colour discord to reinforce statements about actual disharmony between elements in the composition. The theory of colour discord provides that colours fall into a natural sequence (yellow the lightest, then orange, red, through green and cyan, eventually to blue and violet as the darkest), and that when shades are arranged in any other order – for example, a red that is deeper than its neighbouring blue – a discord results. Although colour discords are frequent in nature – the pale blue of chicory among the bold yellow of mullein in a railway siding, or poppies mingling with cornflowers in a barley field – they are normally thought of as uncomfortable combinations and can therefore be used as unsettling compositional devices, emphasizing disharmony.

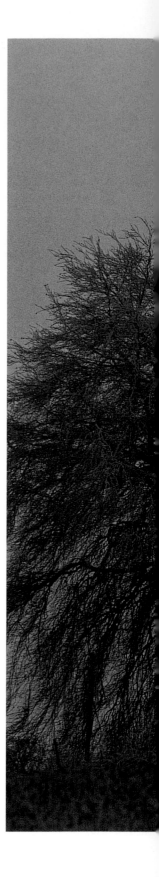

**Cottage**

*A freezing fog was beginning to descend as I finished a session photographing red squirrels late on a winter's afternoon. With the sun low in the sky, the shaded sides of the trees took on a subtle bluish hue, contrasting with the soft pink of the sky.*

300MM, FUJI VELVIA

**Plantation forest**

*In spite of a heavily overcast sky, the relative brightness of the clearings contrasted with the gloom of the forest, though less starkly than it would have on a sunny day. In these conditions long exposures are called for, in this case 30 seconds.*

HASSELBLAD XPAN WITH 45MM, CENTRE-SPOT ND FILTER, FUJI VELVIA

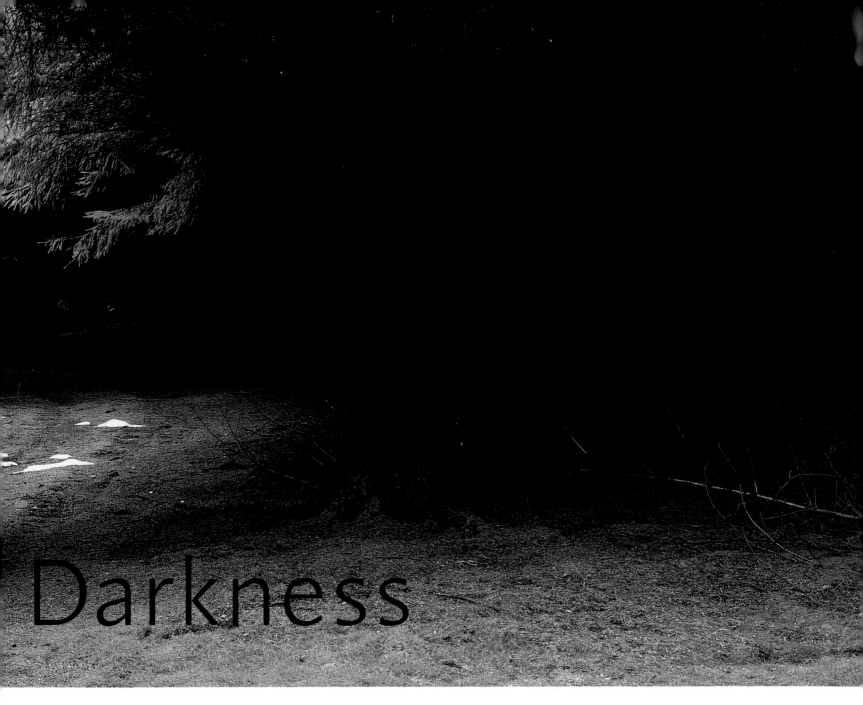

# Darkness

We have established already that 'seeing' is a two-way process. On the one hand, reflected light enters our eyes, sending signals to our brain; simultaneously, remembered colours and shapes, even emotions, inform how these stimuli are processed, causing us to 'see' things that we haven't actually perceived. In other words, we don't have to study every detail of a jay's feather to enable us to identify it and picture the bird it comes from. A glance suffices. What happens, then, when light levels are very low, external stimuli are reduced, and our memory and imagination have to work harder to make sense of the world around us? Is there anything more baffling than being lost at night, alone in an unfamiliar, unlit environment?

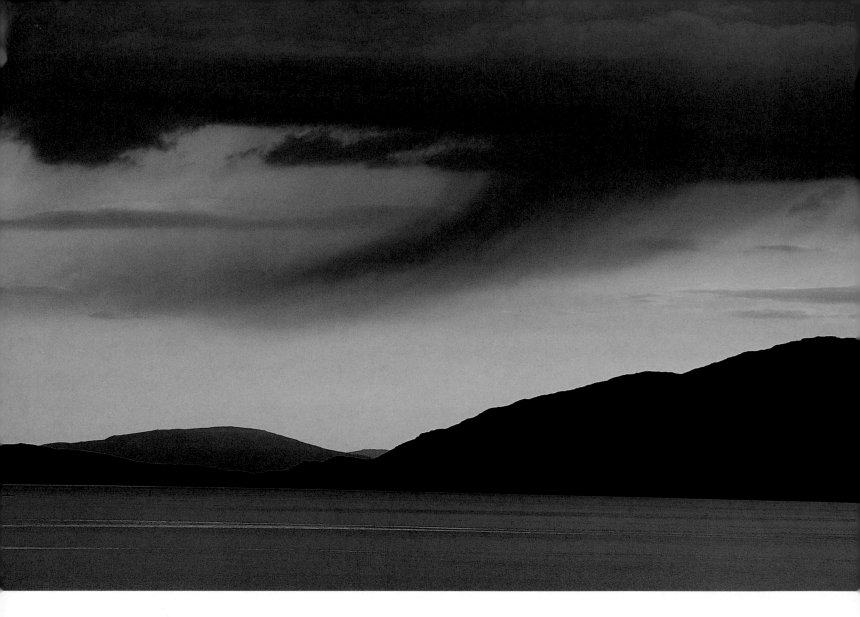

**Passing shower**

*Towards dusk, the previously clear sky began to be menaced by clouds. This shower was the introduction to a night of heavy rain as weather moved in from the Atlantic.*

300MM + X1.4 CONVERTER, BEANBAG, FUJI VELVIA

BEYOND reason is mystery, and in mystery resides wildness. Obscure or fully shaded elements in a composition resonate with this mystery, inviting speculation about their substance. A deep shadow, after all, is a visual void for which the imagination has to create a reality. If the form is recognizable – the shape of a pine tree, for example – then we can fill in the details, but if it is ill-defined, the sense of mystery is heightened. In the controversial artist Anselm Kiefer's sinister book of paintings and photographs, the impenetrable shadows of the forest in the opening image are, in the interpre-

tation of historian Simon Schama in *Landscape and Memory*, guarded by serried trees, almost like the bars of a cage, challenging an entry and probably denying an escape. The interior of the forest is unfathomable, foreboding.

Shadows and silhouettes lack depth, their flatness contrasting with illuminated areas around them, adding to a sense of separation. But the density of a shadow may arise more from the narrow exposure latitude of film than real obscurity. Anything more than 2 stops darker than mid-tone in an uncompensated exposure will be rendered black. So long as we

have very bright highlights (perhaps 3 or 4 stops brighter than mid-tone), we can under-expose the image to ensure that shadows are recorded as black, and introduce our own mystery to the scene.

Pictures in which the foreground and margins are dark, leading into a sunlit middle distance, imply a different relationship with shadows – that the photographer is looking out from one. The impression this creates can lend an optimistic feel to a picture as the viewer is led from the obscure to the clear, from mystery to reason.

The fleeting relationship that most people have with wild nature can be suggested by portraying the figure not as a detailed, integrated element in the composition but instead as a shadowy presence. Ask the person to move during a long exposure. The length of the exposure needs to be balanced with the degree of subject movement: too long and the blur will not be recognizable as a person; too short and the individual will be too well defined. About ¹/4 second works for someone moving at walking pace. If I need to render the figure sharply, I prefer the face to be partly hidden – our natural interest in human faces provides an unwanted focus for

**Incinerator**

*Backlighting gives a good impression of the thickness of the smoke, as well as rendering the chimney as an ominous silhouette. This incinerator was subsequently closed down through consistently failing to meet emissions standards.*

180MM, FUJI VELVIA

the picture in which place, rather than person, is of primary interest. By denying the figure an identity, attention is more evenly divided with the landscape.

### SEPARATING WITH FLASH

Used intelligently, flash can extend the possibilities for controlling the relationship, in terms of light and shade, between foreground and background elements. There may be times when you want to show a person in detail in the context of their native landscape, but daylight alone makes an attractive balance hard to achieve. The 'smart' through-the-lens (TTL) strobes which have revolutionized flash-in-the-field for wildlife photographers (see *The Art of Nature Photography*, Chapter 6), are less useful in landscape work, although for balanced-fill pictures of active subjects within a landscape they are invaluable.

The main problem with a flash gun is that it

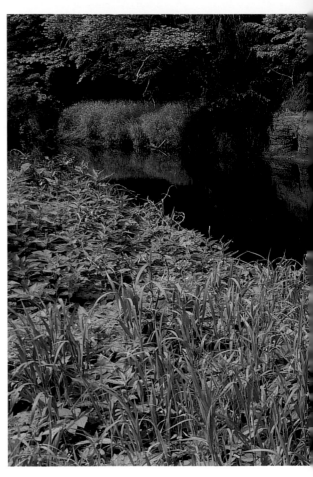

is a small source of light. When used very close to an insect, for example, the flash's window is large relative to the size of the subject, so the insect is effectively enveloped in light. But move it further back and the shadows become progressively harder edged as the light source becomes proportionately smaller (you can confirm this by moving an anglepoise lamp backwards and forwards from a small vase of flowers). Exactly the same happens with the sun on a clear day, but things change when some thin cloud creeps in. No longer does the sun act like a spotlight (or a small strobe) – its illumination is scattered by the clouds making it, effectively, a much bigger light source. The result: soft, even lighting. Brightness and

**Pines**

*I positioned myself in the shadows, darkness welling up all around, and looked towards the brightly lit uplands further down the glen. The recognizable forms of the pine trees made the foreground less mysterious.*

20MM, FUJI VELVIA

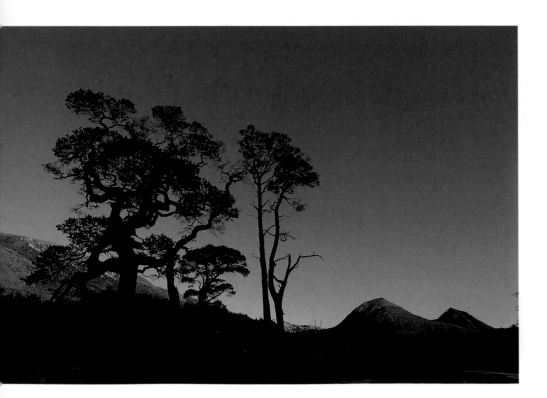

shadow characteristics depend on the density of the cloud. Thin cloud just takes the sharp edge off the shadows without doing much to reduce exposure values, whereas thick, low cloud will act more as a shade than a diffuser, stifling contrast and brightness and dulling colour.

What we need to do with flash is to replicate the soft, yet bright, lighting of thin cloud cover and balance that with daylight in the parts of the scene unaffected by the flash. To that end, we need to make the flash a large light source. There are three main options: it can be fired into a brolly, from within a softbox, or through a sheet of diffusion material. The first two are only really effective with studio-type flashes (Norman and Lumedyne,

among others, produce location versions), whereas the third method works well with a conventional flash gun but is unwieldy.

Flash guns are not very effective with brollies because their beam of light is too tightly focused (even on a wide-angle setting) to illuminate the whole area of the brolly. To achieve the necessary spread of light, the flash would have to be moved quite far back, adding further to the light lost already as it travels to the reflective material, is partially absorbed, then travels back again to the subject. Even with a Norman flash, with the reflector removed to give a very wide spread of light from the bare bulb, the quality of illumination from a brolly is a little harder than with the other two methods.

**River Svetupe, Latvia**

*There are several caves in the sandstone in this part of Latvia, each an invitation to exploration of unfamiliar spaces.*

HASSELBALD XPAN WITH 45MM, CENTRE-SPOT ND FILTER, FUJI VELVIA

**The haymaker, near Lake Kala, Latvia**

*Well, Janis has made haystacks, although he didn't make this one. Working until the job is done, rather than by the clock, is typical of small-scale farming everywhere; the length of the working day is suggested here by the arrival of dusk.*

55MM, FUJI VELVIA

Put a flash gun inside a softbox and the same problem occurs – its output is concentrated on only a small part of the total area. A bare bulb studio or location flash, on the other hand, scatters its light to fill the softbox. If you set a flash gun far enough behind a sheet of diffusing material, its spread creates a suitably large light source, although its power will be somewhat reduced. Remember that the closer the diffusion sheet is to the light source, the smaller the source becomes and the harsher the shadows. As a rule of thumb, I always like to work with the distance between the flash and the sheet at least twice as far as between the sheet and the

subject. The closer a softbox or brolly is set to the subject, the more open the shadows (and, of course, the brighter the illumination).

While it is easy to set a pleasing fill ratio (by means of the the ev compensation setting on the flash gun) with a smart TTL flash, it is a more involved process with studio and location units. A flashmeter is invaluable.

Returning to first principles: if I want the flash light to be very soft, then I set the box close to the subject – typically about 2m away if it is not too large. Let's assume that in this case the subject is a person. The flashmeter reading tells me the aperture to set if flash is

the only source of illumination. Whether or not I go with this reading depends on the contribution of daylight to those elements facing the camera. If a daylight reading reveals that they are more than 2 stops darker than the background, then any under-exposure from the recommended flash setting will under-expose the subject as there is no daylight fill. While this can be attractive when the background is well exposed, if it too is dark the whole picture becomes gloomy. If, on the other hand, the subject is receiving as much direct light as the background, I use the softbox to shade the model so that I can use a straight flash reading. The darkness of the background is then adjusted via the shutter speed. I can

continue to increase the speed (up to the camera's synchronization speed) for a darker background without affecting the lighting on the subject (since no matter how dark the background, the flash is providing the light needed for the subject). If, instead, I choose to lighten the background, I will need to compensate my flash exposure if the gap between the exposures for subject and background becomes less than 2 stops. The balance that appeals to you will become apparent through a process of trial and error, but I find that a 1 stop difference between subject and background calls for an aperture $1/2$ stop smaller (higher number) than recommended by the flashmeter.

## Oats

*A stormy sky was an ominous portent of difficult harvesting weather ahead. In setting the daylight exposure, I under-exposed the sky by 1 stop, thereby reducing the exposure for the oats, too. A simple – 1.7ev fill setting was no longer adequate, since daylight was not contributing so much to the scene. A – 1ev setting struck the balance required.*

20MM, FUJI VELVIA

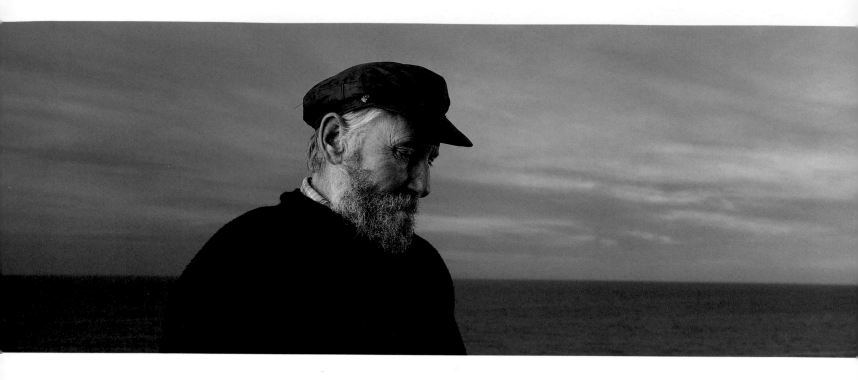

**Man by the sea**

*Without the addition of flash, the side of Pete's head would have recorded as black. I illuminated it fully, taking care to balance the exposure with that for the red sunlight striking his face. Softbox lighting has much more the appearance of natural light than that from a flash gun.*

HASSELBLAD XPAN WITH 45MM, CENTRE-SPOT ND FILTER, NORMAN 400B, IM SQUARE SOFTBOX, FUJI VELVIA

## RECIPROCITY FAILURE

Large format photographers, in particular, often find their exposures running into many seconds, even minutes, as they shoot through tiny apertures in low-light conditions. Two things happen in the long zone: firstly, a colour shift may become apparent in the image, and secondly, the normal reciprocal arrangement, whereby an aperture 1 stop smaller calls for the shutter to be open for twice as long, breaks down. The shutter needs to be opened for longer. The reciprocal works with Fuji Velvia, for example, quite normally up to 1 second. For a 4-second exposure, however, an extra $^1/_3$ stop has to be allowed and a colour-correction filter of 5 units of Magenta is recommended by the manufacturer to counter a shift towards green. For 8 seconds, open up $^1/_2$ stop and add 7.5M; 16 seconds, $^2/_3$ stop and 10M; and for 32 seconds, the longest approved use, open 1 full stop from the good exposure reading and introduce 12.5 units of Magenta. Fuji Provia/Sensia and Astia display much better reciprocity characteristics: Provia can be exposed for up to 2 minutes with only a 1 stop compensation and 2.5 units of Magenta; Astia can also go to 2 minutes with only $^1/_2$ stop compensation required and no colour correction. Figures published by Kodak suggest that their films are generally less tolerant of very long exposures. Reciprocity failure is normally associated with very long exposure, but in fact Kodak suggests that Kodachrome 64 is given an extra $^1/_3$ stop and corrected with CC05 Red for shutter speeds longer than $^1/_{10}$ second.

These are the manufacturers' recommendations, but in a field situation at dawn or dusk colour shifts often go unnoticed and may even enhance an image. Unintentional underexposure does not, however, and it is worth paying attention to the suggested time compensations.

(LEFT) **Birch**

*Three-and-a-half days into a commission shoot with little to show called for steps to counter the unremittingly gloomy conditions. Towards dusk one evening, with no sunset again, I set up a flash gun to the right of the camera and slightly behind the tree to provide a shaft of illumination.*

20MM, TTL FLASH SET TO −1EV, FUJI VELVIA

(BELOW) **Postbox, Bruichladdich, Islay, Scotland**

*On a drizzly but calm morning, sunshine gushed across Loch Indaal in the early morning, sidelighting this postbox by the beach. I lit the front of the box with flash in a big softbox, adjusting exposure so that the background would be darkened.*

55MM, NORMAN 400B, 1M SQUARE SOFTBOX, FUJI VELVIA

### Slioch, Wester Ross, Scotland

*Most visitors readily accept much of the northwest Highlands of Scotland as wilderness. It has all the key elements: high, wild mountains; big, cold lochs; and, here and there, some gnarled old Scots pine. In reality, the area's biodiversity has been under siege for centuries and the landscape is much more barren than it would be in its unsettled state. The electricity poles on the right hint that the place is not as wild as it at first appears.*

HASSELBLAD XPAN WITH 45MM, CENTRE-SPOT ND FILTER, FUJI VELVIA

# Wilderness

Outside of the city, the word 'wilderness' no longer has many of the negative connotations its traditional use implied, and that is in no small part due to the writings of luminaries such as John Muir, Aldo Leopold and Bob Marshall and the photography of William Henry Jackson, Ansel Adams, Eliot Porter and others. But their visions of wilderness were formed on a continent where there were still extensive tracts of land on which the impact of people was at most transitory and superficial. The concept of the frontier, with all its implications for the American self-image, influenced their work at a profound level; the recurring theme – the separation of wilderness from civilization. Wildness (*sic*), after all, is everything that is primal, chaotic, spontaneous and uncontrolled – it is the antithesis of culture. And wilderness is simply wildness in its most absolute state.

AMERICAN ideals of wilderness have been adopted even in those countries in Europe, such as Britain, whose lengthy histories of human settlement and intensive industrialization have long since shattered the integrity required to qualify a landscape as wilderness. If we are to define wilderness as extensive tracts of land where natural ecosystems are intact and where the impact of people does nothing to lessen the land's capacity for self-regeneration, then clearly Britain, and indeed much of Europe, has no true terrestrial wilderness left. But *wildness* persists and is expressed wherever our grip on nature is loosened. In such places photographers can highlight the potency of wild nature, providing a set of reference points as a bulwark against domestication and homogeneity. They can show what we have to lose.

There is a case to be made, I believe, for shunning notions of wilderness and instead concentrating on what the eco-philosopher Arne Naess has termed 'free nature' – those lightly settled areas where natural processes are quite intact but where people also get a living from the land. When Yellowstone National Park was founded in Montana and Wyoming in 1872, the idea of preserving wilderness for its own sake was out of step with the expansionist times; the USA was beginning to feel its strength as a new, self-assured nation and frontier life was a reality for many Americans. But photographs and tales of this extraordinary place swayed Ulysses S. Grant and Congress sufficiently for it to be afforded protection from the commercial exploitation awaiting many other parts of the West. The foresight of its founders not only safeguarded what is now a treasured national monument, but also provided a model of wilderness preservation later copied throughout the world.

Awed by Yellowstone's grandeur and warmed by close encounters with its animals, it is easy to lose sight of an uncomfortable truth about the place: in Yellowstone, there is simply no meaningful co-existence between people and the land. In exercising self-restraint, we have made ourselves outsiders. With the exception of some photographers, guides, writers and Park staff, people nowadays do not get a living from the land of Yellowstone. While ring fencing is often the only practical real-world response to the grossest assaults on wild nature, it unintentionally, but implicitly, legitimizes the abuse of those areas outside – just as the concept of nature reserves, and wilderness photos free of any human traces, reinforce the idea that people and nature are not only separate but mutually antagonistic. Little pockets of wilderness are no substitute for an overall vitality of wildness – the store of potential. If we are interested in portraying connection and co-existence in our

**Elk Antler Creek Meadow, Yellowstone National Park, USA**

*Large parts of many American national parks are, by virtue of difficult access, effectively out of bounds to casual visitors, and natural processes carry on unhindered. Even at this meadow by the road, there are no obvious signs of human intervention in the landscape.*

90MM, FUJI VELVIA

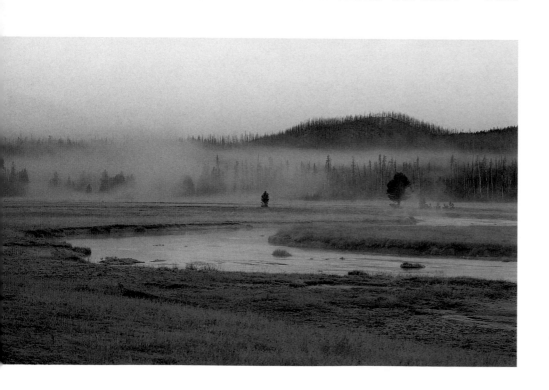

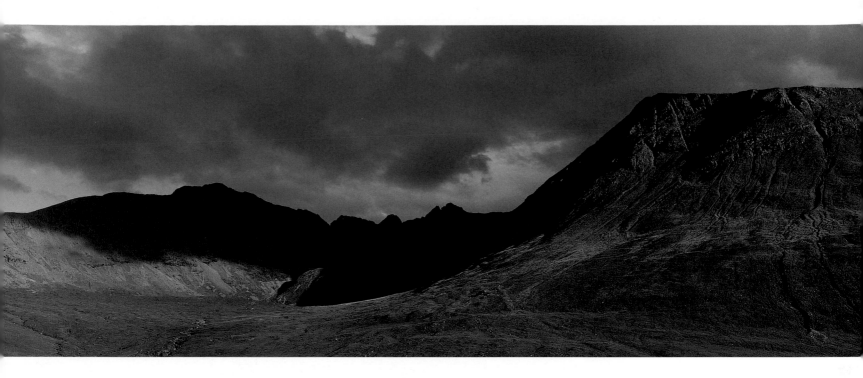

pictures, then continuing to emphasize the *otherness* of wilderness does not serve this goal. In the real world, aesthetic appreciation can never replace dependency as a reason for people to value the land over a long period.

There is more than a hint of fundamentalism in the exclusivity that is a prerequisite of wilderness preservation – somewhat at odds with the freedoms of the wilderness described by John Muir. This may be one reason why wilderness images are so popular: the absence of man promises the absence of control and the liberty to act at will. Yet wilderness maintenance demands rigorous controls and checks, and structures to enforce them. And no matter how laudable the aims of the organization administering the wilderness, resentment at the curtailment of freedom can build, particularly among those with different land-use priorities. Restating the wilderness ideal endlessly in our photographs does little to move the debate forward.

## RETHINKING WILDERNESS

Few of us will ever spend time getting to know an extensive wilderness area. We are, at best, curious onlookers on passage. But the essential desire of landscape photographers to illustrate the energy of nature and capture beauty can still be satisfied in wild landscapes that are more accessible. It is all a matter of scale and avoiding explicit reference to human activities – if you can justify doing this.

We learn from the sublime tradition in painting that to communicate the raw power of nature the photographer needs to satisfy the viewer's need to be awed, but from a comfortable distance. The wide-angle picture that takes the viewer into the middle of the waterfall or beneath a cornice is troubling – there is a stronger sense of the potential danger of the situation. This diminishes through a telephoto lens, implying as it does safe distance. In these situations, most viewers are happier to be onlookers than participants. Many have a

### Coire na Creiche, Skye, Scotland

*The Cuillins was one of only two ranges in the British Isles that protruded above the ice cap during the last glaciation. This exposed their tops to thousands of years of frost shattering, shaping the ragged skyline we see today.*

HASSELBLAD XPAN WITH 45MM, CENTRE-SPOT ND FILTER, FUJI VELVIA

**Loch Garten,
Inverness-shire,
Scotland**

*Primeval forest has
long since disappeared
from the Scottish
landscape; never-
theless, protected
areas in the central
Highlands, such as
Abernethy, retain
many of the charac-
teristic pine-wood
species. These pockets
of forest are both a
reminder of what has
been lost and an
inspiration for what
could be re-established.*

300mm, Kodachrome 64

similar reaction to the proximity of the horizon. When it is close – perhaps formed by mountains towering overhead – the picture has a more oppressive feeling than when it is distant, such as on the prairie or tundra. Along with the sky, the horizon is a major determinant of the emotional tone of a picture. The horizon also helps to define scale in a photograph more clearly than just about any other point of reference. Photographs that exclude it are ambiguous about the extent of the wild area and have a more intimate feel, appropriate to small pockets of wildness. A horizon, however, also lends depth to a picture and when omitted, alternative techniques to suggest distance – such as the exaggerated perspective of a wide-angle lens or setting warm and cool colours side by side – need to be used.

We can validate our claim to an area's wildness in pictures that challenge the received wisdom about how things should be in nature. If they don't conform, they are, by implication, uncontrolled and therefore wild. A healthy woodland is supposed to be comprised of upright trees all reaching for the sunlight. Well, wander through the primeval forest of Bialowieza, straddling the border between Poland and Belarus, and you will find a mix of trees, living and recumbent, dead and standing, all contributing to its vitality. Tree species here are hard to distinguish by profile; oaks, which at home bough out at a few metres above the ground, in the Polish forest grow straight and tall for 20m (65ft) or more before any sizeable branches appear. Here, hornbeam is not the familiar demure hedging species but a huge bottle-brush vying for canopy space.

Yellowstone, too, provides an interesting case study of the ability of wild nature to confound expectations. Despair at the

desecration of this national icon which followed the firestorms of 1988 soon gave way to a recognition of the fire's creative powers. Where there had been dense, uniform lodgepole pines, there appeared a mosaic of meadows and clearings and a luxuriant carpet of pine seedlings, liberated from their cones by fire. This was vigour and renewal that a century of fire suppression following the Park's inception had inhibited. On reflection, a hands-off management policy seemed inspired rather than neglectful.

## WORKING IN WILDNESS
In her acclaimed book *On Photography*, Susan Sontag rationalizes holiday picture-taking, especially by those with a highly developed work ethic, as an appeasement of the anxiety about having fun. Photography becomes a 'friendly imitation of work', a way of justifying time away from the workplace. For some, though, the same effort that goes into their professional lives is, during holiday times, redirected into their photography. It is hard, then, to travel to a remote area, perhaps at

**Glen Esk,
Angus, Scotland**

*Although many of the locations I work are not especially remote, I rarely meet anyone else at them, making the self-deceit of being in a wilderness easier to practise. In the Highlands, a high value is placed on 'the view', something that would be obscured in this and many other locations if the natural forest were present.*

20MM, FUJI VELVIA

considerable expense and, in spite of trying very hard to find 'the picture', to come away with nothing. It is very easy to conclude that the trip was a waste of time.

Sometimes wild nature is just too slick to imprint on film: it looks shiny and attractive, but didn't evolve to be photographed and, in spite of our best efforts, evades fixing. The problem often stems from expectations of a place, as if advance research or payment of hard-earned money to a guide guarantees the images fixed in one's mind. Wild nature, of course, is completely oblivious to human effort and rewards randomly. Some photographers, sometimes, just get lucky.

Over time, I have learned to expect nothing of a place, but to hope for everything. Previsualized images normally accompany any photographer at the start of a trip, but I try to shed these as soon as I can, to be open to what I am seeing rather than preoccupied with what I am imagining. Often the statement about a place's wildness is found not in the imagined grand vista but in the intimate space, something that does not become apparent until you are there.

(ABOVE) **Black Cuillins, Skye, Scotland**

*On the morning of my departure from this location, the clouds in the east lightened sufficiently to allow some pre-dawn exposures – the blue tones matching the tranquillity of the scene.*

HASSELBLAD XPAN WITH 45MM, CENTRE-SPOT ND FILTER, FUJI VELVIA

**(RIGHT) Stuc Coire an Laoigh, Wester Ross, Scotland**

*Beinn Eighe is Britain's oldest National Nature Reserve and is managed by the government agency Scottish Natural Heritage. As is often the case, some of the most impressive views are to be seen from the bottom of the hill, although the climb onto the 900m (3,000ft) high ridge takes only a couple of hours.*

80–400MM AT 200MM,
FUJI VELVIA

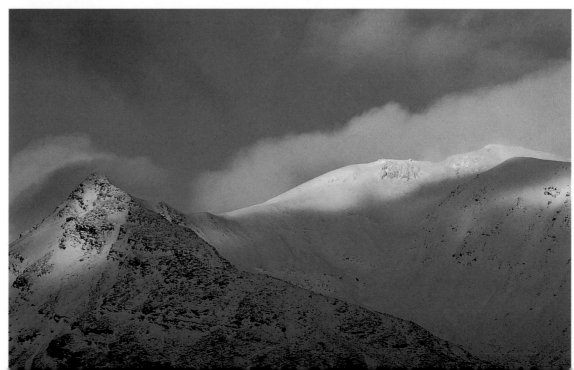

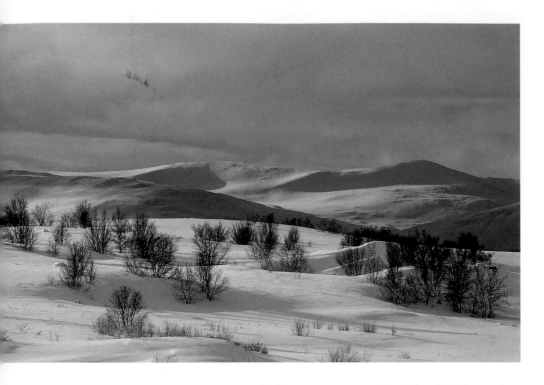

Can it be linked to other elements that are relevant to the picture's theme? One at a time, these components are incorporated into the composition, until the inclusion of anything else threatens to reduce the impact of the core topics. More often than not, the horizon is that step too far. Though these compositions may not be on the grand scale of the Yosemite vista, they can be just as valuable as records of wildness.

Wildness, not wilderness, is the dynamo that powers evolution and change. It is the true character of the land, the real measure of a landscape's vitality. Its capacity to surprise confounds the photographer working to an agenda but inspires the one who approaches it with an open mind. In wildness, we can sense at once our limits and our potential.

**Dovrefjell National Park, Norway**

*No longer considered bleak wasteland, wilderness attracts visitors in their droves. Control is inimical to the wilderness experience, but in Dovrefjell in winter you meet the mountains on their own terms and watch out for yourself.*

55mm, Fuji Velvia

Unless you are particularly skilful at using the harsh light of midday or the gloom of an overcast one, you are most likely to work in the full-bodied light of dawn and dusk. In middle and higher latitudes, that leaves a big gap in the middle of the day. This is the time to learn the landscape, to connect with it. Once you know it well, then images can be previsualized, compositions determined for when the light comes good, or later in the year when the colours have turned. The landscape reveals itself to the patient observer.

When we encounter a wild scene with obvious visual appeal, the first decision to make is what stays and what goes. Compositional choices might be limited by features such as fence lines or utility poles, but in the absence of these the main question is, 'What is relevant to the story and what is not?' I find that in these situations it helps to start off by thinking small. Begin by identifying one of those elements that caught your attention in the first place.

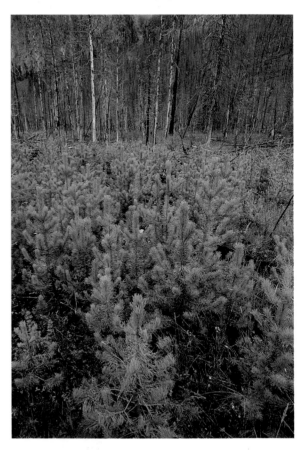

**(ABOVE) Frozen pool, Bialowieza, Poland**

*I took this picture from beside one of the few trails through the core area of the ancient forest in Bialowieza. Visitors here must be accompanied by a guide, not only to ensure that they behave respectfully but also to prevent them from getting lost; once off a trail, this can be accomplished in less than 2 minutes.*

Hasselblad Xpan with 45mm, centre-spot ND filter, Fuji Velvia

**(LEFT) Lodgepole pine seedlings, Yellowstone National Park, USA**

*With an average elevation of about 2,400m (8,000ft), the growing season on the Yellowstone plateau is relatively short. So, eight years after the firestorms, these seedlings, feeding on the ash-enriched soil, remained quite short. Intense competition between them will eventually see the carpet thin.*

20mm, Fuji Velvia

**(BELOW) Coll, Argyll, Scotland**

*In Britain, remote beaches and coastlines probably have the strongest claim to near-wilderness status; here, the influence of man is at its most tenuous and always vulnerable. The sea is not easily subdued. It is no coincidence that these are often the most biologically productive areas.*

20mm, −2 stop ND filter, Fuji Velvia

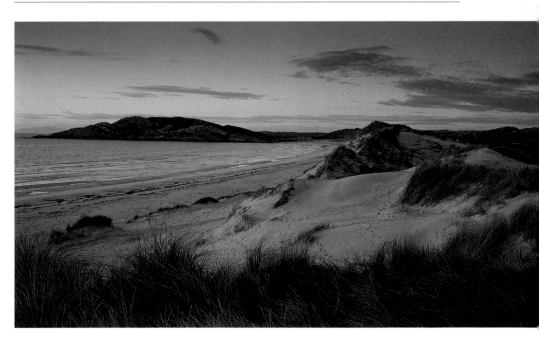

### Wind farm

*Grazing, forestry and energy generation all in
the one view indicate a heavily utilized landscape.
Nevertheless, wild nature finds a place in field
margins and along the forest edge.*

HASSELBLAD XPAN WITH 45MM, CENTRE-SPOT ND FILTER,
FUJI VELVIA

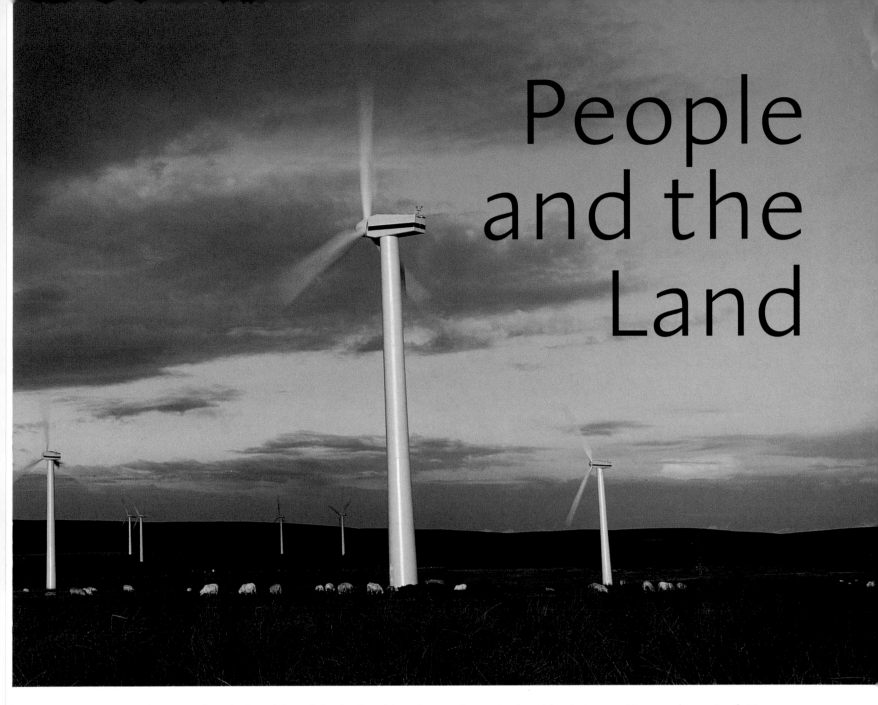

# People and the Land

For many centuries, man's relationship with the land has been characterized by intervention and manipulation. The culture of management is deeply ingrained in almost every custodian of the land, irrespective of their aesthetic or economic motives. To do nothing is considered reprehensible. In approaching the settled landscape, the photographer should be aware of the opportunities to comment on our success, or otherwise, in reaching an accommodation with wild nature. The photographs themselves can chart our relationship with the land, the successes and failures, over time. They may even go some way to answering the age-old question of what is a good way to live on the land. Are the needs of modern people and wild nature necessarily mutually exclusive?

(LEFT) **Overgrown barn, Pennsylvania, USA**

*Wild nature is quick to reclaim property vacated by people. Here I was drawn by the harmonious colours of the Virginia creeper and the woodwork.*

28MM, FUJI VELVIA

(RIGHT) **Photographer at dusk, Kemeri National Park, Latvia**

*Life in a photograph is always a compelling presence. Though small in the frame, our attention goes directly to the figure, partly because he contrasts well with the lightest part of the sky.*

20MM, FUJI VELVIA

'...the massively spreading oaks that became an almost obligatory feature of portraits painted by Gainsborough now advertised not merely the substance but the patriotism of the sitter.' He refers to the tree-planting programmes undertaken by estate owners during the seventeenth and eighteenth centuries, principally of oak, which would provide the timber required for building the ships on which this island nation relied to assert its place in the world, particularly once rapid colonial expansion began. In the twentieth century, the requisitions of war once again highlighted the shortage of domestic timber stocks, leading to the formation of the Forestry Commission in 1919. This marked the start of large-scale, state-organized industrial forestry, which would radically alter the appearance of both upland

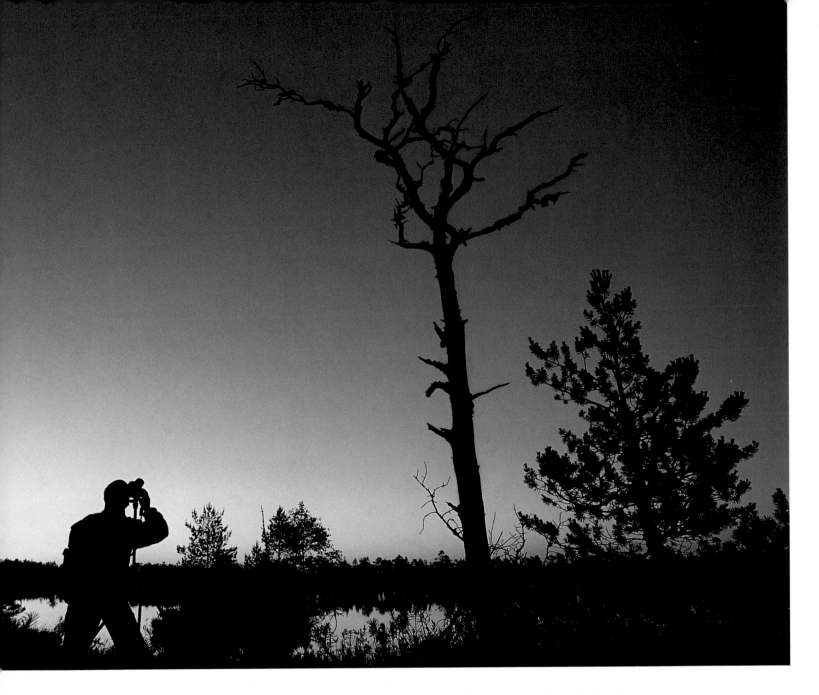

Britain and marginal land in the lowlands. Non-native species, such as Sitka spruce, were chosen for their ability to thrive on nutrient-poor, wet soils. Silvicultural techniques such as deep ploughing (with the saplings planted on the ridges between the drainage channels) allowed trees to grow, if not thrive, in places where natural conditions had conspired against forest cover. The political landscape we

photograph is one superimposed on the land.

While the use of technology to meet particular land use objectives was nothing new, the twentieth century saw its sophistication expand exponentially, its success in overwhelming the processes of wild nature unmatched in history. This was most clearly evident in intensively farmed areas of the Great Plains of North America, and of western

**Dead fox**

*More than just about any other mammal in Britain, foxes polarize opinions between town and country people. Had this individual opted for an urban life he could have expected a less violent end: his diet of discarded takeaways would have caused less friction than one of pheasant or grouse chicks.*

55MM, FUJI VELVIA

Europe, where the drive for self-sufficiency and demand for cheap food from government and public after the 1939–45 war reshaped both the landscape and the population's relationship with it. Ever fewer took a living directly from the land, and with the shift from shortage to surplus in several agricultural sectors, attitudes to land use once again began to change.

Even if we are aware of the forces that have shaped the landscape we want to photograph, it remains hard to rise above the prevailing tide of opinion and present the elements objectively. But we should try, nevertheless, in the certain knowledge that attitudes and priorities change over time. How many Europeans would have thought in the 1950s, for example, that productive land left untilled was anything but wasteful? Yet, at the start of the twenty-first century, setaside land (a European Union scheme whereby some fields on a farm are left uncultivated in exchange for subsidies on crops from the rest) is viewed positively by many people, particularly those who rank the importance of conservation alongside that of food production. In portraying the effects of this scheme on the land, are you contrasting a colourful riot of wildflowers with an austere backdrop of wheat monoculture, or celebrating the productivity of the land alongside a messy field of weeds? Ultimately, that judgement is the viewer's.

## ATTITUDES TO THE LAND

With the freedom from hunger that the majority of people in the industrialized world now enjoy, the land is viewed increasingly as a place in which to feed the soul as much as the body. This is fertile ground for the photographer who wishes to portray the tensions between the people who work the land and those for whom it is simply a setting for leisure activities.

Issues of access to hill country in Britain, and wider conflicts over rural developments such as quarrying and dam building, highlight the polarization of attitudes that often exists.

Photographs of people enjoying the countryside state, above all else, a need for open space and escape from the physical confines of the city. In these pictures, the person has equal status to the landscape and there is less need to obscure identity. If they are clearly enjoying themselves, I like to portray that; it affirms an attachment to the land, even if the landscape is a managed one.

There are also marked national differences in the way people enjoy the land, mirroring deeper attitudes towards it. In Britain, for example, gathering mushrooms and berries is no longer the popular family activity in autumn that it remains in Scandinavia and the Baltic States. British industrial history is a long one

**Child among bluebells**
*Whenever the subject's face is shown clearly, interest is diverted from the landscape. If, however, the place is making the person look happy or solemn, it is, indirectly, being acknowledged.*
300MM, TTL FLASH SET TO −1.7EV, EKTACHROME 100S

**Hill walker**

*By going in very close with a wide-angle lens, in relation to the landscape the figure is dramatically overstated.*

20MM, TTL FLASH SET AT −1.7EV, FUJI VELVIA

and the knowledge of what is good to eat has long since been lost by most people. The Norwegian principle of *allemannsretten* – every man's right (to roam) – and the constitutional encouragement of *friluftslivet* – the open-air life – is in marked contrast to the British experience, where there is general acceptance of legal systems that support the right of individuals to limit the access of others to their land. This makes it easier to channel people into relatively few 'hotspots', such as National Parks, where they and their activities can be better managed. People, like the land itself, are subjects to control.

Cemeteries also provide an interesting insight into national sentiments towards the land. While the theme of resurrection, represented by evergreen trees and shrubs, is a constant one, the settings vary widely. In many Western urban cemeteries, little tolerance is shown of wild nature; typically, where

budgets provide, they are manicured, linear, and planted with sombre evergreens to reinforce the solemnity of the place. In many ways, they are extensions of suburbia, and are maintained with the same determined orderliness. This is a way of showing respect for the interred; even in death, wildness must be resisted. In some rural churchyards, however, there is no such pretence and over the centuries a diverse grassland/woodland flora develops, maintained by infrequent mowing. Diversity and abundance of life somehow seem a more fitting tribute. This is more in keeping with the Baltic model, where cemeteries are frequently located in the forest, the graves planted between the trees and accessed by gravel paths.

Perhaps you are looking for nothing more than an attractive, well-lit composition. But if you are as concerned about the content as the appearance of your photograph, don't be afraid to analyse what you see before tripping the shutter. The creative photographer of the settled landscape (if s/he is of an optimistic disposition) is in a perpetual search for signs of reconciliation, for evidence that an accommodation has been reached and that we have learned to balance give with take. Among some conservationists there is a growing awareness that less intervention rather than more, though unpredictable in its consequences, is sometimes the best option. In any event, management plans are expensive to implement and, by definition, limited in their scope compared to wild nature's inventiveness. 'Re-creating wilderness', be it in our photographs or on the ground, is nothing more than a beguiling oxymoron.

**Graveyard, Skye, Scotland**

*In a wild setting, against a rugged skyline, a neatly mown lawn and alien yew seem strangely out of place. They can be seen as superfluous tokens of reverence in a landscape already dominated by symbols of endurance – the mountains – themselves in harmony with the line of gravestones.*

HASSELBLAD XPAN WITH 45MM, CENTRE-SPOT ND FILTER, FUJI VELVIA

# City and Garden

**Edinburgh Castle, Scotland**

*A low viewpoint not only made the castle stand out in magnificent isolation from the city below, but as a bonus provided a colourful background as I pointed the camera towards the richest blue of the sky.*

Hasselblad Xpan with 45mm, centre-spot ND filter, Fuji Velvia

For the photographer, the city presents a paradox. On the one hand, it represents the triumph of culture over nature, the controlled over the wild, more completely than any other environment. Yet the photographer need only scratch the surface to reveal a latent vitality: the peregrine falcon nesting on a high-rise; the red valerian reaching for the light from a grimy wall; the Oxford ragwort seeds riding on the slipstream of a commuter train to colonize new territories. What from a distance appears to be the complete replacement of wild by cultural processes, on closer inspection is exposed as a facade, breached whenever we slacken our grasp.

## Making connections

**Canning factory**

*First impressions can be deceptive: this factory is producing nothing more noxious than steam. The suggestion that the emissions might be more sinister can be attributed to the addition of a pale warm-up filter.*

300MM, 81A WARM-UP FILTER, FUJI SENSIA 100

Whether our hearts belong in the city or the country, we have all grown up in the industrial age whose seat of power is in the city. Our collective cultural alignment is industrial rather than agrarian; our material needs are met and we are physically nurtured by industry rather than by subsistence. As a consequence, our knowledge of the connections within the natural world has diminished while our understanding of the relationships within the urban environment has grown. It is not a strange place. The signs that guide us are explicit compared to those offered by the natural world: one uses the word 'Danger', the other signals with purple spots. At a glance, we can make an assessment (accurate or otherwise) of a person's lifestyle and social standing; we can make no comparable judgements of non-human species without protracted study. Irrespective of a photographer's intention, a photograph 'means' only whatever the viewer sees in it, but in the most familiar context, the city, there is a better chance that the two interpretations will accord with one another. Like it or not, the city is our world – and we define wilderness against it.

Perhaps it is this level of understanding

**View from Calton Hill, Edinburgh, Scotland**

*Here, symbols of the worldly and the spiritual are juxta-posed, the church subdued alongside the brilliance of the bank headquarters.*

300MM + X1.4 CONVERTER, FUJI VELVIA

**Courtyards, Leeuwarden, the Netherlands**

*While depth is enhanced with a wide-angle lens, the absence of a horizon, or even a skyline of rooftops, lends the scene a claustrophobic feel.*

20MM, FUJI VELVIA

people become mere subject matter rather than the individuals they are at street level. The menace of dark spaces is diminished by distance and buildings become elements in a composition rather than places for living or working. The city, in other words, is made more understandable, less intimidating.

Capital cities offer the photographer the chance to represent relationships beyond their physical boundaries. Not only is a nation's cultural and economic wealth frequently concentrated in its capital, but the city's structures reflect the nation's current or past status in the world. The wealth required to build great cities such as London and Paris cannot be generated internally – it has to come from military or religious conquest and/or, as is the norm today, trade in the wider world. The buildings in the heart of the city themselves may be statements of corporate or political self-image, current or historical, and these provide a focus around which the photographer can build the rest of the composition.

Growing homogeneity characterizes the 'world' city in the post-modern era, as the globalization of popular culture and corporate transnationalism hold sway. Just as wilderness has its icons, so too do the world cities. Some may be old – St Paul's Cathedral and the Tower in London; others new – La Sagrada Familia in Barcelona or the Opera House in Sydney. These structures symbolize each city in the public mind as powerfully as Uluru symbolizes the Australian outback or Buchaille Etive Mor the Scottish Highlands. And as national identities become more diffuse, so these icons assume a new importance; they help, in a superficial way, to restate national identity. If we are to assume that stock catalogues reflect the pictures that people demand, then we can conclude that

that makes the urban landscape so overwhelming when we approach it with a camera. The chaos of forms found in the natural world gives way in the linear city to a tangle of connections. And just as the photographer of wild landscapes is drawn to the physical edges of a place, so the city photographer is drawn upwards in search of the overview. The detachment of distance simplifies; seen from afar,

**Castle at dusk,
Edinburgh, Scotland**

*Calton Hill gives a
good overview of
the eastern part of the
city centre. From a
distance, the buildings
become mere elements
to be balanced in the
composition rather
than places where
people live and work.*

300MM, FUJI VELVIA

**Greyfriars Bobby, Edinburgh, Scotland**

*From a discreet distance, I watched a steady procession of visitors come to look at one of Edinburgh's icons. Everyone took a photograph, usually before looking at the plaque. Some simply videoed the statue and plaque, and then headed off to the next piece of urban scenery without actually 'seeing' the statue.*

AF 300MM,
FUJI SENSIA 100

viewers want to see pictures that celebrate diversity rather than confirm uniformity. They are full of images of the Golden Gate and Eiffel Tower, the Leaning Tower of Pisa and Taj Mahal, not street-level shots of the fast-food franchises, chain stores and international corporations familiar the world over. Yet the photographer interested in conveying connection, at a local level or on a larger scale, does better to focus past the obvious symbols of individuality and look instead for the universal.

The lure of the incongruous in wild places – the telephone box in the middle of the moor or an abandoned car in a forest, for example – is no less powerful in the city. And because our sense of things or people out of place is more acute in the familiar environment of the city than in wild nature, we can explore more fully

**The Scott Monument, Edinburgh, Scotland**

*This Gothic monument dominates Princes Street, but the statue of Sir Walter Scott nestling within its base is more modestly proportioned. Here I set out to reduce the ostentatious spire to a minimum and focused instead on the author himself.*

180MM, FUJI VELVIA

**Swedish whitebeam in a close**

*I hunted for some time for an image that would illustrate the idea of disconnection in an urban environment. As soon as I glanced down this close, I knew I'd found it. The process was deliberate, even laboured, but at least gave me a thread to follow through all the other conflicting themes the city experience presents.*

**55MM, FUJI VELVIA**

themes of disconnection in the urban landscape. While an image of a forest of rhododendrons (native to the foothills of the Himalayas) on a west Highland hillside will not strike the average viewer as especially odd, one of a bowed, homeless person begging outside an international bank does: we understand the irony better. Yet both are images of displacement and disconnection.

As in the managed countryside, land that is unused in a city, where wild nature is busy reasserting itself, is normally looked on unfavourably. It presents a challenge to the order of the city and is described in negative terms: 'waste ground', 'derelict land' and sometimes, ironically, 'wilderness'. It looks a mess. Wilderness within the city is regarded with far

less tolerance than that outside. Such green spaces, on the edge between culture and wildness, are intriguing to photograph; not only are they incongruous (or is it the city forming the backdrop that is incongruous?), but they raise the question as to whether it is the green space or the city that is under threat.

The reality, of course, is that it is almost invariably the green space that will be overwhelmed, often to make way for roads or car parks. Although telecommunication technology has lessened the importance of the road as a conduit for information, our passion, our *need*, for personal mobility profoundly shapes the city and the lives of those who live there. In the same way as the coming of the railways made suburban life possible in the nineteenth

**Window box**

*The linear, slightly austere order of this Georgian building is punctuated here and there by brashly coloured window box displays of cultivated flowers. Contrast this with the Pennsylvanian window on page 86.*

180MM, POLARIZING FILTER, FUJI VELVIA

tographic repertoire, taking the content of our pictures beyond attractive light, colour and form. Should not the garden, whose principal object is to delight our senses (or feed our body), be free of such concerns? Can we really read anything into a bed of petunias?

I would contend that the ambiguous relationship we have with wild nature is more evident in gardens than in any other environment, and that alone makes them worthy subjects for critical photography. A garden at once celebrates natural beauty – the structured progression of hues in a herbaceous border by Gertrude Jekyll – while eliminating plants and animals that have no place in their creation. In it, different species are associated

and twentieth centuries, so road building enables the continued expansion of the city into green space and, for many of us, broadens the choice of where to live. Like the city, the car is itself a paradox, at once representing personal freedom and choice while exacting a heavy toll in environmental and social terms. The car, and our dependency upon it, are rich veins to be mined by the city photographer at a time when ownership and use relentlessly increase, with all the unresolved issues that accompany unfettered growth.

### IN THE GARDEN

In this chapter, as in the previous two, I have merely recounted my own response to different environments and suggested that we should think about what we are looking at, rather than taking it at face value. There are no rights and wrongs, no definitive how-tos. By taking time to reflect, we can deepen our pho-

for aesthetic rather than ecological reasons. Genetic freaks – contorted hazels and fasciated willows, which in the wild state are up an evolutionary dead end – are, along with mutant colours, cultivated and valued. The garden, in short, is nature with the stamp of culture on it.

Yet photographs of gardens and people enjoying them refute the notion that we can live apart from nature. In them, we can see a reconnection with nature (albeit a contrived version) taking place. It happens on any number of levels, from the cactus on the office desk or window box brightening a drab building, to the earnestly maintained suburban garden that provides the antidote to the stresses of weekday life in the city. Indeed, as a place to photograph people working the land, handling the soil and growing things, the garden provides many more opportunities than does the open countryside in the industrialized world.

Gardens are expressions of other people's creativity; in a thoughtfully laid-out display, much of the photographer's work has been done already in terms of the arrangement of colour, composition and focal points. By talking to, and thus understanding the intent of, the gardener, we can make photographs that convey his/her vision clearly, unmediated by our own interpretations. It is then up to the viewer to draw conclusions about the gardener's empathy with the land.

**Derelict land**

*Developers sometimes acquire pieces of land but do nothing with them for a while; as the land turns into 'wilderness', local opposition to a controversial development may diminish as frustration grows at the neglect. In the city, order is always the preferred state. This is one interpretation of the scene here.*

HASSELBLAD XPAN WITH 45MM, CENTRE-SPOT ND FILTER, FUJI VELVIA

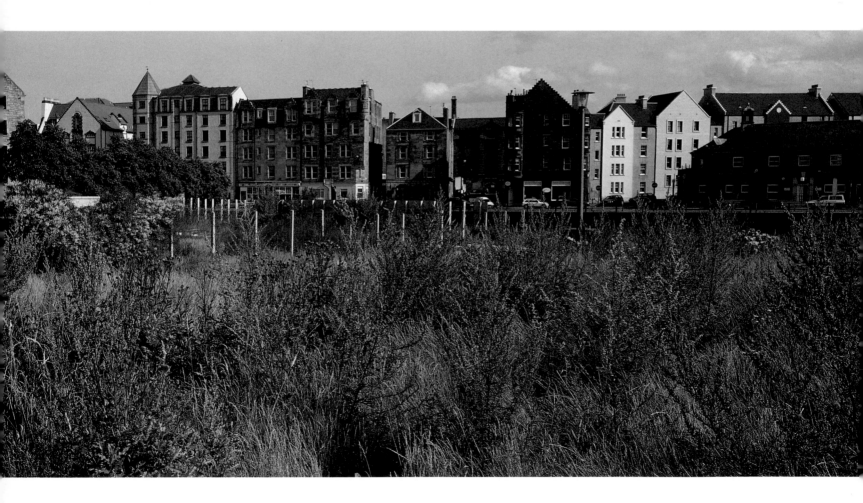

### Nacreous clouds

*During the most spectacular show of nacreous clouds
seen in eastern Scotland for years, I sought out the
most colourful and shapely section, settling on this rift.
This phenomenon results when light diffracts through
thin clouds composed of evenly sized water droplets
and is best seen against a darkening sky.*

AF 180MM, FUJI VELVIA

# The Intimate Landscape

The intimate view is the humble version of the grand vista. From its narrow set of references we can extrapolate wilderness, allowing our imaginations to roam freely. It simplifies the complexity in a scene, revealing the photographer's preferences and aesthetic sensibilities. Lighting, even perhaps the elements themselves, can be controlled to an extent impossible in the wider landscape. This possibility of control gives rise to a tension between how nature is and how photographers *would like it to be*. On the intimate scale, the conflict between natural expression and aesthetic convention is at its most intense. Nature, in other words, is a mess. It needs to be ordered. But as James Gleick comments in *Nature's Chaos*, '. . . the human mind seems to take as little pleasure in a straight line as in pure formlessness.' The most successful pictures, it seems, coax order out of a matrix of chaos.

### Scorched bark, Wyoming, USA

*After photographing a mass of burned trees near Mount Washburn in Yellowstone National Park, I homed in on one whose contrasting yellows and blacks caught my eye. At this scale, the fragility of the bark, and therefore the tree, is more evident.*

90MM, FUJI VELVIA

scape on a larger scale has been portrayed in the USA: it is a history of a search for the divine.

It may seem odd to include pictures of clouds in a section about intimate landscapes; the sky, after all, is the grandest vista of all and utterly uncontrollable. Yet without a horizon – the reference point with which we most readily construct scale – the details of skyscapes become as abstracted as those in a piece of sandstone at our feet. Alfred Stieglitz's black and white series *Equivalents*, created over a long period around his country retreat in up-state New York, was the first to celebrate clouds and skies as subjects in their own right rather than simply as setters of emotional tone for the landscape below. Eliot Porter, working with the heightened emotions of colour, produced his own series of skyscapes.

### Norway spruce

*A severe winter gale felled a number of Norway spruce beside my home, splitting some open in the process. The heavy rain that accompanied the winds soaked the wood, enhancing the colour of it and the needles strewn all around.*

90MM, FUJI 50

An understanding of abstraction is the key to making successful photographs of the intimate landscape. In photography (excepting the possibilities of digital manipulation), we are dealing with forms that exist, not the novel forms of abstract painting. But by reducing the viewer's sphere of references, these forms become 'abstracted'. On one level, the process of abstraction is about concealing the subject's identity, done most effectively by confounding the search for its outline – our primary response in object recognition. The purpose of abstraction is to concentrate the viewer's attention on the subject's colours, textures, shapes and forms, a process inhibited by recog-

nition, which brings with it the baggage of prejudice and preconception. The photographer, quite simply, has to exclude edges that will speed the identification of the subject.

## Techniques

Close-up work is a steady process of exclusion and refinement, until all that is left in the frame is the essence of the subject. It is a quiet, absorbing discipline quite different from the excitement of chasing light in the greater landscape. Take the camera off the tripod. As I search for a close-up image, I repeat like a mantra 'life, light, precipitation, colour' – the four catalysts that can transform a good

**Ice-coated rushes**

*In sub-zero temperatures, water splashing out of a culvert gradually coated these rushes with thick ice. The dark culvert itself formed the background; my lens's narrow field of view ensured that no distractions would creep in.*

300MM + 52.5MM
EXTENSION, FUJI 50

**Beaten water**

*Once it has dashed over a couple of small waterfalls near the Highland Boundary Fault, the peat-stained North Esk slows and swirls languidly in a deep black pool. Foam beaten up in the rush turns with the currents to form these patterns.*

300MM, FUJI SENSIA 100

picture into a great one. If something strikes a chord, I then think in terms of edges. So, where is the most extreme example of what I'm looking at – the most vivid contrast of colour, form, shape or texture – then, where are the subject's edges that I need to exclude? Only once I'm satisfied that I've met these aesthetic criteria do I set up the tripod and arrange lighting.

Large-format photographers often comment favourably on the discipline these tools bring to their work. They are slow to use in comparison with 35mm SLRs, the viewfinder image is upside down, and they lack many of the conveniences of the miniature format such as built-in exposure meters and long film lengths. You don't rush things with large format and you think twice before exposing any expensive sheets of film. But there is no reason why 35mm users should take any less care: the goal of in-camera perfection (or as close as can reasonably be hoped for) is a common one,

after all. Indeed, the fact that it is much easier to set up another composition with 35mm if the first isn't quite right should encourage the photographer *not* to settle for second best.

### LENS CHOICE

Setting aside the opportunities for portraying depth afforded by tilt/shift lenses (see pages 129–30), most of our close-up work will be done either from directly above or from the side. Assuming that we want all the details of the picture to be sharp, make best use of the available depth of field by paralleling the film plane with the principal plane of the subject. Set up the camera obliquely and you are, effectively, wasting depth of field. While it is easy to determine the principal plane of a tree trunk, that for a tangle of vines may be less obvious, and it then becomes a matter of stopping down the camera to the shooting aperture and moving it around until most of the relevant parts of the composition are sharp.

A medium to long telephoto, with its narrow field of view, gives the user greater control over the background than does a shorter lens. Given the choice, I use a 180mm on a 27.5mm or 52.5mm extension tube (to enable closer focusing), but if background elements remain too clearly defined, I change to a 300mm with the bigger tube. The background appears softer because of the greater magnification of out-of-focus elements. A shorter telephoto in the 85–105mm range is more suited to compositions from above. I'd advise against anything shorter. Not only will you be forever shading the subject, but if it is something ephemeral like frost, the heat from your breath and body at close range will affect it. A short telephoto also gives enough working distance between the camera and the subject to allow the introduction

**The spate**

*For attractive colour contrasts in water, find a stretch in the shade that reflects a hillside lit by the setting sun. The birch leaf lodged firmly on a mossy rock just beneath the water's surface provided an incongruous note of stillness.*

300MM, FUJI VELVIA

of reflectors and other lighting devices.

True 'macro' lenses can focus so closely that the subject appears on the film at the same size as it does in real life, a 1:1 ratio. Rarely in the field is it practical to work at a greater magnification. As with an extreme telephoto, subject movement and camera shake (as well as a tiny depth of field owing to magnification) become limiting factors in the pursuit of technical perfection. A lens that can focus to a 1:2 ratio (half life size) covers most of my needs. When more magnification is called for, I rack the lens out to its closest focusing point and then insert the shortest extension tube I can. The further the lens's aperture diaphragm is from the film plane (it effectively becomes a smaller point source of light), the greater the loss of image sharpness through the effects of diffraction. This is a process whereby light rays are scattered when forced through a small aperture, making it hard

**Oak leaves**

*Around the margins of the leaves, the surface tension of the water reflected the clear blue sky while the puddle itself, fortunately, remained in the shade.*

90MM, FUJI VELVIA

**Pebbles and footprints**

*Granite is a rock that seems to be pacing itself for eternity: it resists erosion like few others. I was attracted by evidence of the passage of a small bird – the ephemeral and the permanent side by side.*

55MM, FUJI VELVIA

**Eroded sandstone**

*The sea has gnawed away at a Lower Old Red Sandstone conglomerate cliff-line near my home to produce a pebble beach dotted with red and green jaspers and sparkling white quartz. With every tide these continue the work of ages, grinding depressions, mortar-and-pestle fashion, into the wave-cut platform.*

90MM, 81A FILTER, FUJI VELVIA

to bring them back to a point of focus. Diffraction happens even at large apertures, but isn't apparent until a small one is selected. The same problem occurs even without additional extension when the lens is stopped down to f22 or f32. If you are unable to hold everything in the composition sharp at f16, it is better to back off, thereby reducing the magnification, than to stop down further to increase depth of field.

Extension, whether built into the lens or added as a tube, is normally the best way to achieve magnification. But the more extension you add, the more light is lost on its way to the film. A 90mm f2.8 lens which gives a 1:2 magnification ratio has 45mm of extension already built in. To take it up to 1:1, another 45mm is added. However, at this ratio the maximum effective aperture is no longer f2.8 but f5.6 – a 2 stop loss. Extension factors are a nuisance if you are lighting the picture with manual flash;

which measures the light reaching the film plane. If the subject is static, light loss may not be an issue unless it takes you into the realms of reciprocity failure (see page 68). If you have subject movement to contend with, screw-in positive dioptre lenses increase magnification without causing light loss, allowing the selection of a faster shutter speed.

The methods we use to achieve sharp results from telephotos apply equally to close-up work. If the camera and lens cannot be supported on a beanbag (the most stable method of all, because of the greater surface area supported), stabilize the tripod by minimizing its extension, while keeping the head upright (see pages 130–31). I also weigh mine down by stretching a bungee cord between it and my camera bag on the ground. At high magnification, it is sometimes easier to find focus by moving the camera backwards and forwards rather than racking the lens. A long plate which can be slid to and fro on an Arca Swiss-type quick-release platform is a cheap, if less refined, alternative to a focusing rail. If your camera has mirror lock-up, use it to reduce pre-exposure vibration. If not, allow the camera to settle for a few seconds between exposures or a momentum of shake can build up. This is especially acute when using long lenses on tubes on a tripod. Don't then waste all this effort by triggering the camera by hand: a cable or electric release minimizes your contact with the camera and the risk of introducing shake.

## THE RIGHT LIGHT

I spend a lot of time scrutinizing the ground through half-shut eyes – not because I've lost my contact lenses, but because it gives me a quick indication of the contrast in a scene. If

shadow detail disappears altogether, I know that there is probably more contrast than the film can handle. A more reliable method involves spot metering the most important highlight and the shadows and seeing if they fall within the 4 stop range. If not, exposure compensation may be called for.

Perhaps my most useful, and certainly cheapest, lighting accessory is an opaque plastic sheet. When the sun shines through it on to

**Sand ripples,
Cape Kolka, Latvia**

*For once, I shot obliquely (hence the slightly odd perspective), stopping down to f16 to maintain foreground-to-background sharpness.*

90MM, FUJI VELVIA

**Amber, Slitere, Latvia**

*Although amber's origins are organic, it is regarded as an ornamental stone. I moved the piece my companion had found into a position where the low sun grazing the beach would illuminate it, but where the sand itself remained in shadow. All the other elements were already present here.*

90MM, FUJI VELVIA

the subject, the contrast range is compressed, as shadow values are lifted by about 2 stops with only 1 stop lost on the highlights. Importantly, too, the resulting light is luminous rather than flat (as you would associate with the even lighting of full shade), preserving bright colours and introducing subtle modelling to curved surfaces. While a reflector lifts shadow exposure values, it does nothing to suppress the brilliance of highlights and, for evening out contrast, is of limited use.

Gloomy light is almost as unattractive as full sunlight for close-up work. Without some brightness, even well-exposed images look flat

and the colours dull. Sometimes, a silvered reflector is all that is needed to add the sparkle required, especially if the subject is in local shade. But on 'pancake' days, even a silver reflector is of limited use. This is the time to bring out the diffusion sheet again, only this time you provide your own personal sun in the shape of a TTL flash.

The most sympathetic, natural-looking lighting combines diffused flash with daylight, a technique that also achieves balance with those areas of the composition not lit by the flash. Start off by setting the good daylight exposure for the subject with the diffusion

sheet in place. Then, take control by over-riding the automatic fill setting and adjust the ev compensation on your TTL flash to − 1.7 stops (see *The Art of Nature Photography*, Chapter 6, for details about using 'smart flashes'). This means that the flash will provide almost 2 stops less light than is needed for a 'correct' exposure − just enough to add brightness in the shadows without overwhelming the subtlety of the soft daylight. TTL flash metering makes this whole enterprise straightforward and predictable, but is only really practical with units that feature separate ev compensation. The diffusion sheet is essential to the success of this technique and ought to be held as close to the subject as practical. The flash should be at least twice as far from the diffusion sheet as the sheet is from the subject, to create as large a light source as possible (see page 66).

(ABOVE) **Mammatus clouds**

*Thunderstorms are an infrequent occurrence in my part of the country and the chances to photograph these pendulous formations are few. Mammatus clouds are caused when warm, moist pockets of air on the underside of the thunder head are forced downwards by a process of reverse convection.*

90MM, KODACHROME 64

(LEFT) **Cirrostratus clouds**

*While waiting for pink-footed geese to come to roost, the striations of this formation coloured up attractively. The geese, unsurprisingly, elected to fly against another, less attractive, part of the sky.*

300MM, FUJI VELVIA

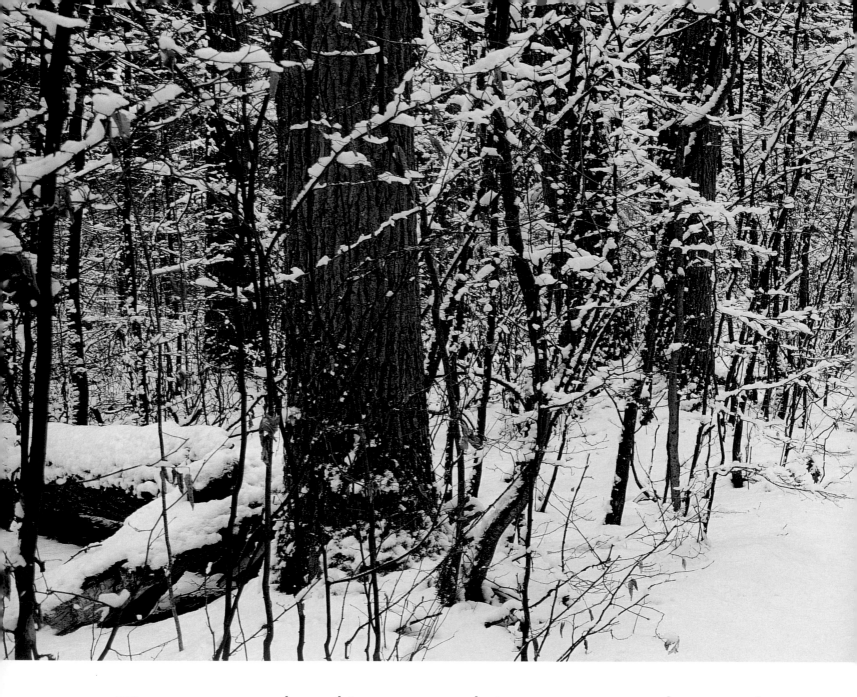

*...Two roads diverged in a wood, and I –*
*I took the one less traveled by,*
*And that has made all the difference.*

**from 'The Road Not Taken', by Robert Frost**

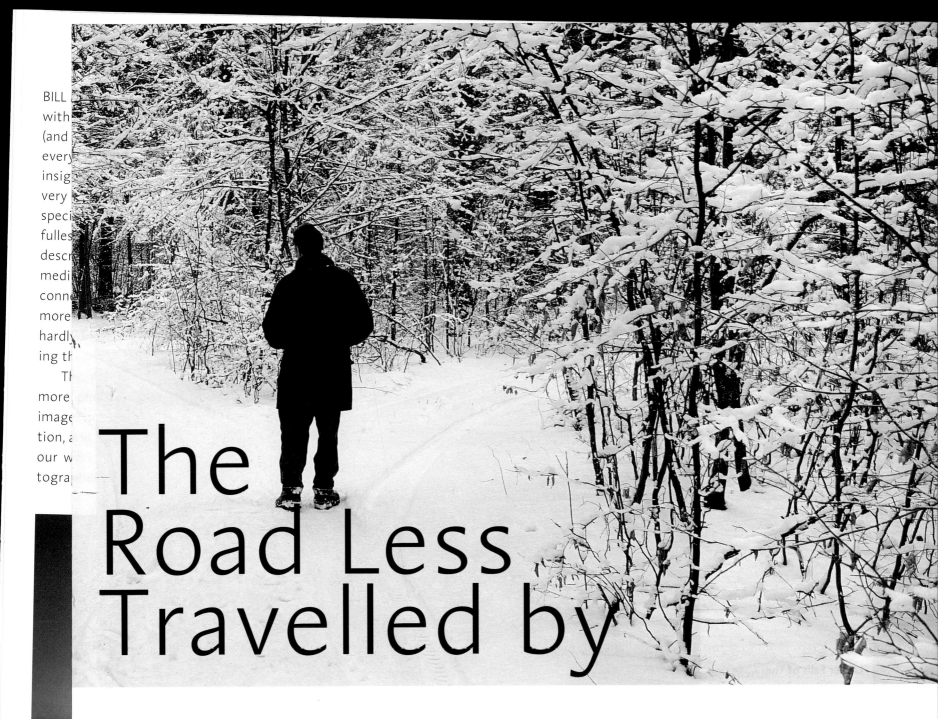

# The Road Less Travelled by

When American writer Bill McKibben, author of the prophetic *End of Nature*, published 'The Problem with Wildlife Photography' in the fall 1997 edition of *Doubletake* magazine, he provoked a storm of protest among its practitioners. In the article, he suggested that since such a huge amount of photography already existed of the natural world, particularly of the 'charismatic megafauna' (lions, elephants, dolphins and so on), a moratorium should be imposed on the professional production of any more. Editors have enough choice as it is, so why continue to invade the lives of our subjects to get yet more pictures?

**Two roads in the wood, Bialowieza, Poland**

*Here is the scene in the Polish forest which I describe at the start of this book. What, at the time, felt like pure reaction now looks increasingly like metaphor.*

HASSELBLAD XPAN WITH 45MM, FUJI VELVIA

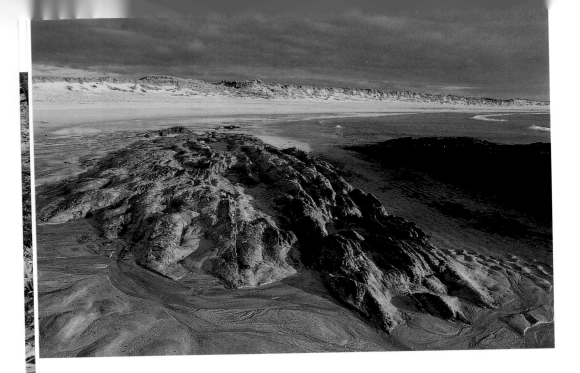

**Seaweed-covered rocks, Coll, Argyll, Scotland**

*I sometimes wonder how often I will have to return to this bay before I know it properly; on each visit, a fresh set of lines is revealed or the wet sand reflects the light in a different way. Curiosity draws me back time after time.*

20MM, −2 STOP HARD-STEP ND FILTER, FUJI VELVIA

island of Coll. Coll and its neighbour, Tiree, enjoy the longest hours of sunshine in Britain, in part because of their northern latitude but also because the 'Atlantic weather' passes over them on its way to meet the mountains of the mainland. I can be fairly sure of at least a couple of good evenings during each summer visit.

The bay itself is an empty stage where, without the distraction of an elaborate set, sky, sand and water come together to perform their own dramatic dialogue. Dynamic environments, such as beaches, are especially suited to this 'blank canvas' approach, not least because of their endless change and the variety of moods they display as the weather, too, changes.

It seems ironic, perhaps, at a time when environmental abuse is rife, that most landscape photographers (myself included) remain preoccupied with the superficial beauty of light and form, and doggedly peddle images which suggest that all is well in the wilderness. Photographs, of course, are a form of consolation, but if they are used to provide collective as well as personal consolation, viewers without direct experience of a place are misled. Many

times I have focused on the one pristine section of a landscape, and in doing so implied that it is representative of a greater whole; more often, it is just a fragment of what once was.

Clearly, for the professional photographer there are economic reasons for doing this. Experience shows that a subtle, thought-provoking shot will be passed over in favour of the dramatic, colourful one in nine cases out of ten. And if the image disturbs a popularly held notion, it is unlikely to appear in print at all. Over the past 20 years or so, the picture industry – both photographers and agencies – has become much more sophisticated and targeted. There is, generally, a much higher degree of professionalism than before; we now know what will sell and production is geared accordingly. It would not overstate the case to say that some locations have become little more than commodities to be endlessly repackaged, then sold on again. Other places are neglected and are, by implication, less worthy of care, second rate. I think there are dangers when professionalism edges ahead of passion. It is all too easy to lose sight of why we started taking pictures in the first place – usually out of love for the natural world – as the economic imperative becomes the driving force. If financial reward is the primary motive, then we may as well photograph centrefolds and give the wilderness some peace.

A different perspective on the 'problem with wildlife/landscape photography' is offered in Barry Lopez's essay 'Learning to See', in which he describes a growing realization that his photography was getting in the way of his appreciation of experience and memory of detail. Photography, in this respect, is quite unlike painting, where the finished canvas is, in a sense, not the main outcome of the exercise;

it is what happens to the painter as s/he works through the painting, examining, questioning the subject matter, that endures and informs all subsequent work. Photography was working against Lopez's ability to evoke in words aspects of an experience beyond the medium's reach. Since the visual component of an experience is often quite a small one, maybe this should concern us all. Photography may give us the means to say something, but too often, in the face of sublime beauty, we are rendered speechless and the photographs become a set of random words rather than a coherent statement about a place.

The complexity of a place, it seems to me, cannot be revealed in a single photograph any more than it can be described in a single sentence. The 'thousand words' said by the photograph are a catalogue of contents, not necessarily a revelation of the relationships within it. We need in the first instance to learn the words that describe a place, before we start to assemble them in a photograph. This is quite different from the instinctive reaction to light and form I described on page 8. If we take this approach, we soon realize the need to return to a place, to make a set of pictures representing different chapters of the same story.

(BELOW) **Loch Beinn a'Mheadhoin, Inverness-shire, Scotland**

*This picturesque glen is one of the most photographed in Scotland, but there remain many possibilities for the photographer willing to leave the trail and seek out his/her own viewpoints – and to rise early in the morning.*

90MM, 81A FILTER, FUJI VELVIA

(LEFT) **Sandstone arch, Angus, Scotland**

*The sandstone features on the Angus coast may be tiny compared to well-known areas in the USA, but they nevertheless merit more attention than they currently receive. Were that the case, casual vandalism – principally chiselling names into the rock – might be regarded with less indifference.*

20MM, FUJI VELVIA

RGB image in your hand, look instead at Fuji Pictrography prints which, when well made, can serve as final art for scanning.

When affordable photo-realistic inkjet printers first appeared, many photographers, myself included, were so impressed by their superiority over previous generations of printers – and excited by the control offered by digital imaging – that complicated issues of colour management and gamut were often overlooked. Now that the general level of knowledge about things digital is more advanced, our collective attention is focused on

*Imacon FlexTight Precision II Scanner*

matching the screen image to the final print as closely as possible. This will never be perfect, of course: the image on screen is in RGB while the one on the page is only a CMYK approximation. But it can come close, and the highlight and shadow detail that can be reproduced in a digital print – assuming that a first-class scan is used – is superior to that of either R3 or Ilfochrome prints made directly from slides.

The first stage in achieving a good match is to calibrate your display, either by using the Gamma Control Panel in Adobe Photoshop or by having the job done by a bureau with the specialized hardware and software. If you work with an uncalibrated display, there is no telling how an image that looks marvellous on your screen will look on someone else's. It also provides a fixed reference point from which to make adjustments to your printer's driver (the software responsible for how the print looks).

Once the monitor is calibrated, you then need to decide which RGB editing or work space to use. This will affect the way in which the colours of the scanned image are displayed and

*Epson Inkjet Printer*

whether they can be reproduced. The choice of work space is a fraught area, as the producers of consumer desktop scanners and printers have settled on sRGB as the default, while imaging professionals eschew its limited gamut and currently advocate Adobe 1998 RGB (found in Photoshop 5.5 onwards) instead. sRGB was developed for relatively undemanding users and, as far as high quality reproduction is concerned, it cannot even reproduce

the whole range of CMYK colours, and is especially poor in respect of cyan. Just as important a consideration is the particular space into which the images are scanned in the first place. They should always go into the widest space, ideally LAB, which is compatible with Photoshop; scanning into a narrow space such as sRGB may allow all the colours of the scan to be displayed, but colours beyond the monitor's gamut which can be reproduced are lost at the outset.

The default settings on inkjet printer drivers often need to be tweaked to achieve a good match with the on-screen image, but remember that within any RGB space some colours will fall beyond the CMYK gamut. These can be displayed in Photoshop by going to View>Gamut Warning. Furthermore, if your chosen work space is sRGB, its inability to handle cyan satisfactorily will be reflected in the print output, so an image with a large cyan component will print less well than one without. No matter how many readjustments you make, you won't improve the overall colour balance and some images will just print better than others.

Although the original slides were scanned to the size at which they appear in the following section (make the scans too large and information would have to be discarded; make them too small and interpolation – or the invention of pixels – would have to take place, too, with implications for reproduction quality), I did not

apply Unsharp Masking (USM) on completion of the digital work. By increasing edge contrast, USM gives the impression of a crisper image, but the amount to apply depends entirely on the end use of the image (print needs higher settings than screen display) and output size. USM can also have the effect of emphasizing 'noise' (such as pixel clumping) in the scan; check the different channels to see which has suffered and apply USM to the other channels. Once the mask is applied you cannot get rid of it, so it is best always to store one version in an unsharpened state so that it can be re-sized for other uses.

Matching vision to image

There now follow eight examples of applying digital imaging techniques. I undertook the work on the scans in a Macintosh computer, still a popular choice among imaging and design professionals. The software packages used were Adobe Photoshop 5.0 and Ultimatte KnockOut, and the Mac ran on 288Mb of RAM. Where I refer to shortcut commands, these are applicable to the Macintosh. To avoid excessive repetition, I describe in detail how to apply a tool or command only once. If it is used again in another, later, image, I simply name the action rather than how to perform it.

*Panoramic cameras are generally unsuited to close-up work. Here, one 35mm image was duplicated 3 times to make a banner, the elements combined to minimize obvious repetition.*

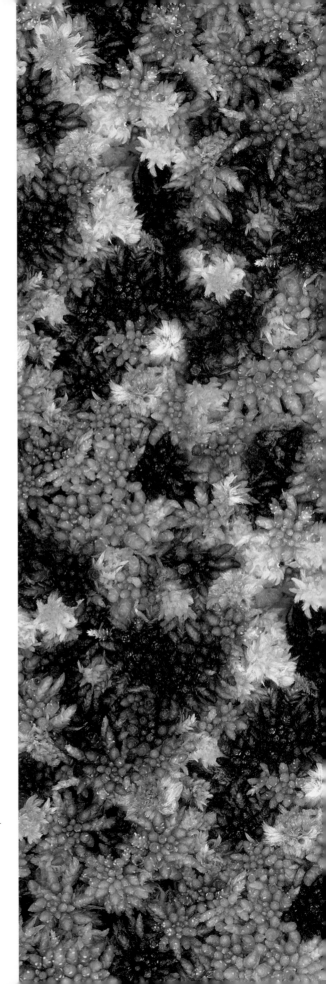

# Mrs Fraser waits on the beach

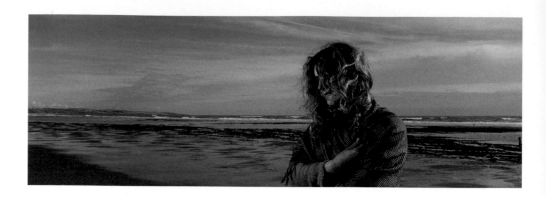

Original photos: Hasselblad Xpan with 45mm, centre-spot ND filter, Norman 400B flash in 1m square softbox, Fuji Velvia

**Concept**: Empty beaches provide the perfect setting for images of isolation. I staged this picture with a model, so that the figure's demeanour and appearance would match the desolation of the scene. The panoramic format reinforced the idea of emptiness while providing more of a distraction from the figure than would have been possible in 35mm. The main practical difficulty in shooting the original elements lay in getting just the right amount of breeze to move Linda's hair, without the softbox that was lighting her blowing over.

**Procedure**: I shot the beach scene with and without Linda; since I was working at f8 (the aperture dictated by the flash's output), it was not possible to render the background and the model in sharp focus. An unsharp background always gives a digital composite a more photographic appearance, but I prefer to start off with a sharp one and choose later how unsharp it should be.

*BACKGROUND*: The most satisfactory way to convert a full-colour image to monochrome is via the Channel Mixer (Image>Adjust>Channel Mixer). I checked Monochrome, then adjusted contrast fractionally by setting blue to 2 per cent. The sepia tone was introduced first by clicking on Colorize, then tweaking the Hue and Saturation values (Image>Hue/Saturation). The post in the water at the right-hand side of the picture disappeared when I Lassoed a small sample of water adjacent to it, feathered the selection by 5 pixels (Select>Feather) and then copied it over the top (hold down the Command and Option keys while dragging the selection).

*FOREGROUND*: I chose Ultimatte KnockOut (now marketed by Corel) to make the selection of Linda. For relatively simple selections, Photoshop 5.0 offers capable tools in the shape of the Lasso, Pen, Marquee, Magic Wand, and, best of all, Colour Range. None of these, however, was capable of making the complex selection of her fly-away hair.

KnockOut needs a lot of RAM to run efficiently – eight times as much as the size of the picture you are working on is recommended. I therefore cropped the original image as tightly as possible before saving it in the native Photoshop format (the first one in the saving options), before quitting Photoshop and opening the image in KnockOut. This stand-alone masking programme works on the basis that there are no edges in a photograph, only transitions, making it ideal for

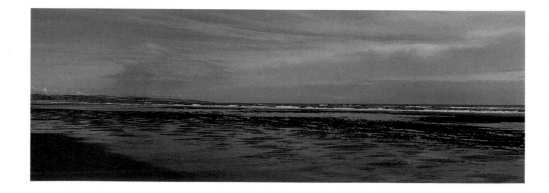

masking subjects with out-of-focus edges and those with varying degrees of transparency, such as glass, steam – and loose hair. Lines representing an Inside Object selection and an Outside Object selection are drawn to define the zone of transition. With this information, the programme identifies those pixels that should feature in the mask, or Alpha channel. I chose a Transition Complexity of 4 (the highest setting), not only because of the nature of the hair but due to the variation in background colours. With the Syringe tool, I ensured that highlighted hairs near the edge of the transition zone weren't lost.

Once the image was processed and exported as a Photoshop document, I opened the Channels palette (Window>Show Channels) and dragged the Alpha channel to the Load Selection button (at the left-hand end of the bar). This selection was then copied and pasted onto the background and the Remove Black Matt command applied (Image> Matting>Remove Black Matt). This must be done with every KnockOut mask. Unwanted pixels that came across in the Alpha channel were erased with the smallest, soft-edged paintbrush.

*FINISHING*: I wanted the appearance of a hand-coloured photograph and found the most convenient way to do this was to set Saturation (Image> Adjust>Hue/Saturation) to – 62. Finally, Linda was rescaled (Edit> Transform>Scale) and moved slightly.

It now remained only to soften the background. I began by duplicating the background layer (Layer>Duplicate Layer) and then applied a Gaussian Blur to it, set at 24 (Filter>Blur>Gaussian Blur). This, of course, completely hid the sharp layer below it and looked too 'out of focus'. I therefore reset the opacity of the blurred layer (on the Layers palette) from 100 per cent (no show-through ) to 81 per cent, which gave an attractive soft-focus effect that works well with sunlit subjects. Gaussian Blurring de-pixelates the selected area, making it appear too smooth and bringing with it the risk of banding. The introduction of Monochromatic, Gaussian Noise (Filters>Noise) at the low setting of 3 restored the effect of film grain.

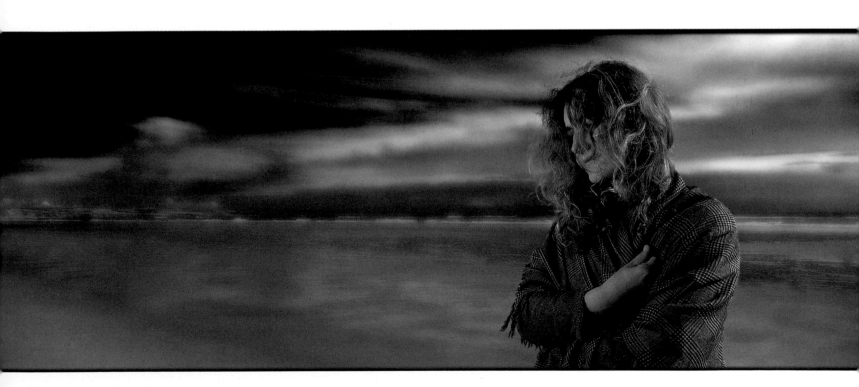

# St Cyrus at dawn

**Concept**: Perhaps the most frustrating aspect of working with a rangefinder (in this case, a Hasselblad Xpan) is the inability to use graduated ND filters with any degree of precision. In this instance, there was such a large difference in the exposure value for the beach compared to that for the sunlit cliff and sky that I had no option but to make two exposures and combine the best of each in the one picture. Used this way, digital imaging is simply reflecting things as seen.

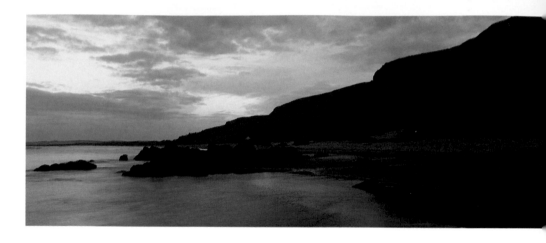

**Procedure**:

*Sky*: With the image pulled up to 300 per cent, I was able to draw an accurate Work Path with the Pen tool to define the skyline. This was converted to a selection (drag down to the third button from the left on the Paths palette), then feathered by 5 pixels (Select>Feather) to achieve a natural blend with the horizon defined by the cliffs and far-away dunes. The well-exposed sky was then copied and pasted (Edit>Copy, Edit>Paste) on top of the existing one.

Even with detail restored, I was still distracted by a large expanse of white at the top left of the picture. I didn't want to remove it altogether since the water reflected the sky, so I set out to lessen its impact instead. I Lassoed an adjacent area of ragged cloud, feathered the selection by 5 pixels and then copied it into the

offending area (hold down Command and Option keys while dragging the selection). To make its source less obvious, I Skewed it (Edit>Transform> Skew) to alter its original shape and

moved it to where it would blend with existing clouds.

*BEACH AND CLIFFS*: On opening the drum scan of the well-exposed beach shot, I was disappointed to find that the

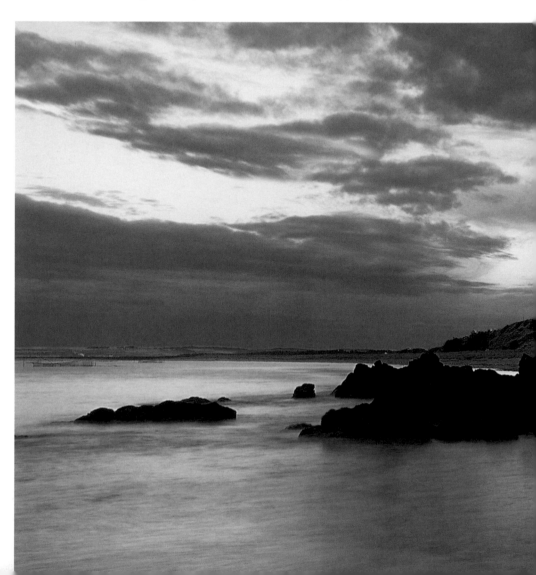

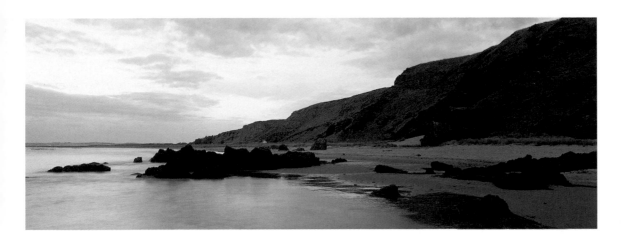

rich morning light striking the cliffs appeared weaker than on the original transparency. I therefore increased its saturation, selecting Reds in the Image/Saturation dialogue box, to

+19. I finished off the picture by copying small areas of sand over a couple of distracting pieces of driftwood and cloning out my camera bags, which, in the rush to catch the

ORIGINAL PHOTOS: HASSELBLAD XPAN WITH 45MM, CENTRE-SPOT ND FILTER, FUJI VELVIA

light, I had neglected to move out of the way first. . .

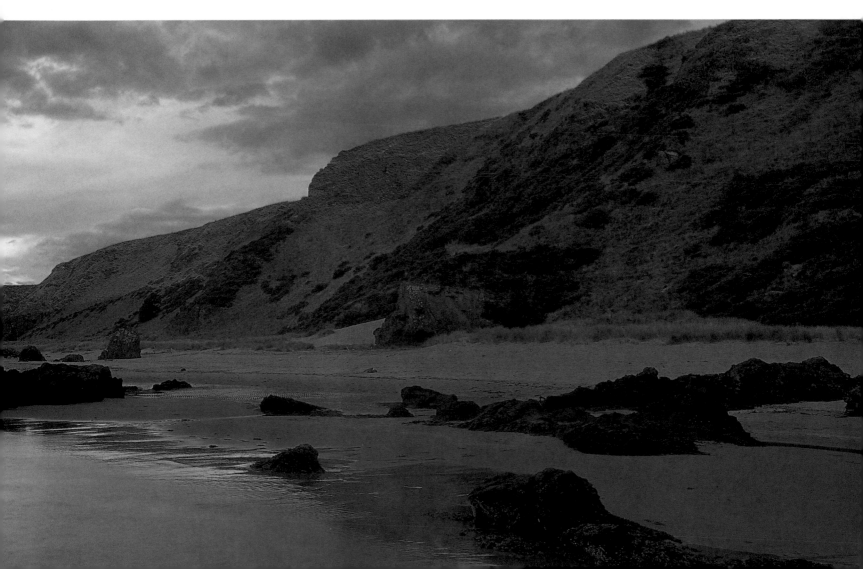

# Dr James Morrison, Whanland

**Concept**: Taking my cue from Magritte's painting *La Condition Humaine*, in which the image on a canvas blends with the real world beyond the window, the Scottish landscape painter Dr James Morrison agreed to feature in one of his own works while he 'painted' what was actually there. The photograph of the scene was taken about two weeks after the painting was completed, by which time the field of winter wheat had been cut – though, mercifully, not baled. I chose a day when the sky resembled that in the painting.

**Procedure**:

*BACKGROUND*: At this stage, the background painting needed no work – I would soften it later once the other elements were composited.

*JAMES MORRISON AND EASEL*: We set up this picture outside his studio on an overcast day and lit it with the large softbox. I tried to match the direction of light in this photograph as closely as I could with that in the original painting, so that the shadows would all point the same way.

The Pen tool proved to be the simplest way of making an accurate selection of James's easel and body. I converted the Work Path to a selection, applied a feather of 3 pixels, and then copied it onto the background. I selected James's head with Ultimatte KnockOut, since the tonal similarity between the rough-cast wall behind and his hair made any Photoshop selection impossible. KnockOut, at a Transition Complexity setting of 4, struggled too, and the resulting selection needed a lot of tidying with a fine eraser once it had been copied into position (and the black matte removed).

*PHOTOGRAPH OF LANDSCAPE*: Not only would this rectangular image have to be made to fit James's board, sitting at an angle to the camera, but part of the layer would inevitably overlap his arms, legs and body. At the outset, I reduced the opacity of the top layer (the photograph) to 70 per cent so that I could see the edges of the board in the layer below. This made alignment much easier and I had only to Scale the photograph, then Distort it (Edit>Transform>Distort) until it fitted the board. I drew a Pen Path around those areas where the painting over-lapped the painter, converted it to a selection and then hit the delete key to remove these pixels. With the upper layer still selected, remaining pixels that were too close to the edge of his smock, hand or brushes to bring into the selection were painstakingly erased with a small, soft-edged paintbrush, allowing the detail on the layer below to show through. I returned the layer opacity for the top layer to 100 per cent. 'Paint strokes' around the edge of the picture were created with the Smudge tool (Tools palette) at a 50 per cent setting. I realized then that the paintbrush had no paint on it, so I darkened its end with the Burn tool (Tools palette).

*BACKGROUND*: With the other elements in place, I could now soften the background. It was important that the viewer could match elements in the background with those in the easel image, so I opted for a low Gaussian Blur setting of 4.6. This was applied to a duplicate of the background

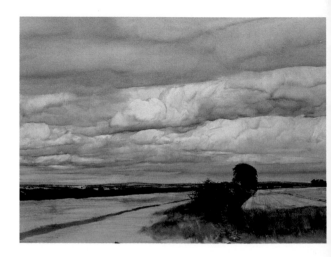

layer so that I could go back later and change the setting if I wished (by deleting the copy and blurring a new duplicate). Photoshop's History palette is invaluable for making retrospective changes during a work session, but after an image has been saved the history is erased. A Monochromatic, Gaussian Noise setting of 5, applied to the blurred layer, restored its texture.

ORIGINAL PHOTOS:
JAMES MORRISON: 55MM,
NORMAN 400B IN 1M SQUARE
SOFTBOX, FUJI VELVIA;
PAINTING: 55MM,
FUJI VELVIA;
LANDSCAPE: 28MM, −2 STOP
HARD-STEP ND FILTER,
FUJI VELVIA

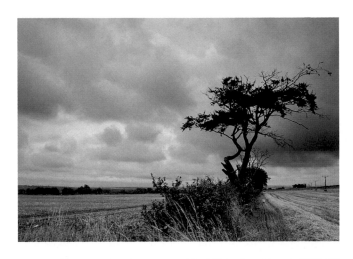

# An Sgurr, Eigg

**Concept**: The Sgurr ('Scoor') dominates the landscape of the small Hebridean island of Eigg. It is a wild, rugged volcanic hill where the visitor feels in a world apart. I wanted to clarify three separate elements in the original picture taken from Galmisdale: human habitation in the shape of the farmhouse; the landscape used and modified by people – the grazed pasture around the farm; and the wilderness represented by the Sgurr itself. I opted to retain the original colour of the house, but to represent the wild parts of the scene in monochrome and to add an extra sense of distance to the hill by selective softening.

**Procedure**: A quick check of Levels (Image>Adjust>Levels) indicated that the scan had captured the complete tonal range of the picture, so I could set to work on the picture straightaway. Quite a lot of tidying-up was necessary around the house. I removed the upper part of the telegraph pole by Lassoing a piece of neighbouring heather, applying a feather of just 3 pixels (much more and such a small area becomes opaque), and then copying it over the top of the pole by holding down the Option and Command keys while moving it. The lower section was removed using the Rubber Stamp tool with a fine brush, while viewing the image at 300 per cent. I

continued at this high magnification for the fine work of cloning out the unattractive railings, using as small a brush as I could to minimize the risk of the cloning becoming obvious. Where practical, I Lassoed and copied nearby areas to block out the railings, and I tidied away the sheep at the bottom left and far right of the original this way, too. It's easy to forget to remove shadows of objects no longer in the picture, so look for the shadow first before hiding any element.

The gable end of the lean-to, over-exposed in the first place, had lost most of its detail in the scan, so I started by drawing a path with the Pen tool around the gable and then converted it to a selection. Foreground and Background colours were sampled from the right-hand gable (in the same light), then a Foreground to Background gradient was drawn to mimic the distemper on other parts of the lean-to. Monochromatic, Gaussian Noise set at 10 provided just the right amount of texture, and the effect was completed with some light strokes from the Burn tool set for Highlights at 19 per cent exposure.

Now I could start the main work. The choice of selection tool is usually dictated by the edge characteristics of the subject and its tonal variation

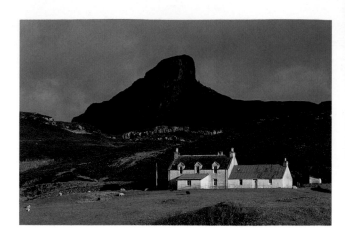

Original photo: 90mm, Fuji Velvia

from the surroundings. In this case, it was simplest to draw a path with the Pen tool around the house. Since this was quite time-consuming, I took no chances and saved it as an Alpha channel (Select>Save Selection). To make it into a selection, I dragged the channel to the button at the bottom left of the Channels palette, then feathered it by 2 pixels to soften the transition into the background. Since it was not the house but everything round about that I wished to change, the selection was inverted (Select>Inverse).

I wanted to make the hill even more brooding by darkening parts of it, so I went to Colour Range (Select>Colour Range), sampled a dark part of it with a setting of 25 and applied a feather of 5 pixels to the selection. I then knocked the middle value in Levels back to 0.74. This, of course, had no effect on the house since it was not selected.

I made the scene black and white

with the Channel Mixer (checking Monochrome) and moved the sliders to: Red +80 (previously 100), Green – 8 (0), Blue 0 (0) and Constant – 3 (0), giving the tonal values I was after.

In the course of conversion to monochrome, I noticed pixel clumping happening in some parts of the sky. Sorting this problem would allow me to introduce the final effect I was after. I drew another Pen Path to define the sky, made it a selection and then expanded that selection by 5 pixels (Layer>Modify>Expand) to introduce the edge of the hill into the selection. A Gaussian Blur of 5 smoothed the sky without introducing banding, while also softening the edge of the hill. Grain-restoring Monochromatic Noise (Filter>Noise>Add Noise) set to 3 completed the picture.

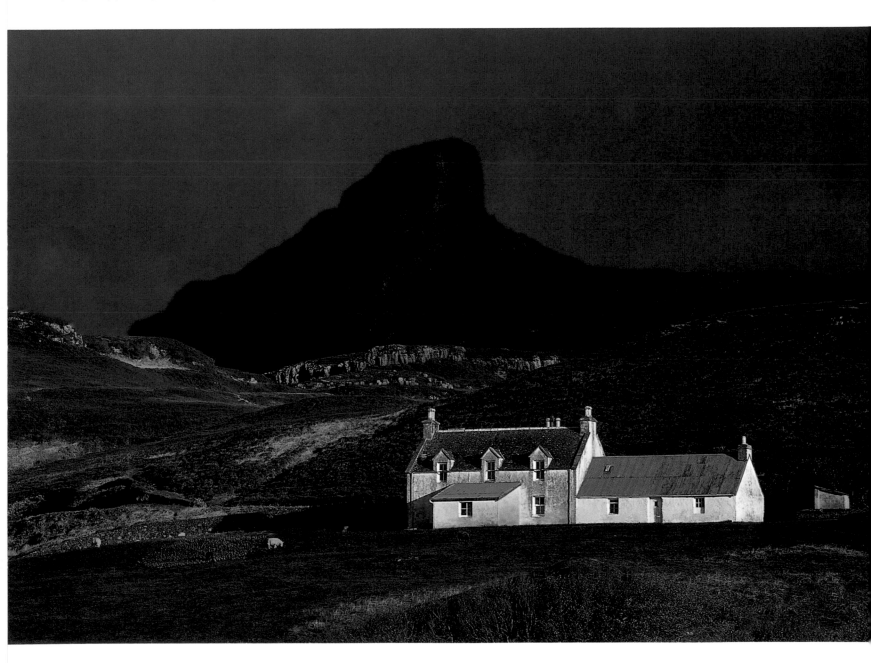

# Nether Kirkyard, St Cyrus

**Concept**: A good deal of photographic technique is concerned with focusing the viewer's attention on a particular part of the picture or reinforcing an idea. While the symbolism in this image is obvious, the lighting conditions at the time were rather at odds with the sentiment of the picture. I set out to create a darker mood.

**Procedure**: At the outset, I decided that the mort house (where relatives of the recently buried would spend several nights to guard against body-snatchers), wall and old man should not be affected by changes made elsewhere in the picture. I drew a Pen Path around them and saved the selection as an Alpha channel.

To darken the sky and sea, I began by selecting them with Colour Range, taking several samples from the different shades of blue and then adjusting Fuzziness until I had a clean selection. I created a new layer by clicking on the middle icon at the bottom of the Layers palette, then copied and pasted the sky into it; I could then control its appearance without affecting any other parts of the image. The sky was darkened in the Hue/Saturation controls by sliding Lightness to −45.

Before I could begin work on the foreground, I needed to copy the mort house/wall element onto a layer of its own so that it would be immune to changes. Masking it would have been an alternative, but since I was about to use other masks, it was simplest to keep it on a separate layer. I was keen to darken the gravestones in the foreground, just as they would darken under a passing cloud on a sunny day, so the transition from light to dark areas had to be gradual.

I did the work on a duplicate of the Background layer so that I would have the option to adjust Layer Opacity later. With Quick Mask activated (click on the right-hand button near the bottom of the Toolbox), I drew an angled gradient (Linear Gradient tool, Transparency ticked) over the bottom left-hand corner of the picture. A graduated red mask appeared, showing roughly the areas that would be affected. This mask was converted to a selection by dragging the Quick Mask Channel (Channels palette) to the Make Selection button (the left-hand one at the bottom of the palette). After exiting Quick Mask (the button beside the first), the red mask disappeared, leaving only lines of marching ants defining the half-way point of the zone of graduation.

ORIGINAL PHOTO: 135MM, KODACHROME 64

I applied a Black fill through this mask selection, darkest at the corner and gradually becoming paler towards the edge of the mask, then reduced the Opacity of the Background copy layer until the shadow was only as deep as I wanted it to be. The wall and mort house now looked rather too bright compared to the areas round about, so I adjusted the brightness with the Composite channel in Curves.

# Machir Bay panorama

**Concept:** Many photographers are now converts to in-computer panoramas, where several 35mm frames are joined seamlessly in Photoshop or a number of other specialist programmes. Since you can use any lens you own and make the panorama as broad as demanded by the subject, there are clearly advantages over a specialized panoramic camera. Nevertheless, the final composition is much harder to visualize (since it doesn't all appear in the frame at once) and there is no transparency to show for your work, unless you have the digital file written to film at great expense. For many picture users, and photographers, that still matters.

The business of shooting the elements for this image of windswept Machir Bay was made much easier by using Canon's 24mm lens with shift facility (see pages 129–30 for a description of the technique). The lens was fully shifted to the left for one part of the picture and fully to the right for the other. One consequence, however, was a fall-off of illumination at the edges. This didn't matter for the left-hand picture since I was shooting almost directly into the sun anyway, but was noticeable in the right-hand element.

**Procedure:** Before anything else, I had to create a canvas (Image>Canvas Size) big enough to accommodate both pictures side by side. The vertical height was just the same as the image's (107.4mm), but I estimated that I would need a canvas about 280mm long to accommodate both pictures once they had been overlapped. The left-hand element was copied onto the new canvas and moved into position. Holding down the Shift key while moving ensures movement in a straight line, vertically or horizontally. Once the right-hand element was copied into place (so that it overlay part of the left-hand one) it was immediately apparent, even allowing for variations in colour and tonality that would be

perceived over such a broad expanse, that quite a lot of correction would be required.

Since the left-hand element was the minor one, I chose it to work on. At this stage, a 'seam' where the right-hand image ended was still visible, but this provided a useful boundary for reference. Referring to the clouds on either side of it and a

ORIGINAL PHOTOS: 24MM TILT/SHIFT LENS, FUJI VELVIA

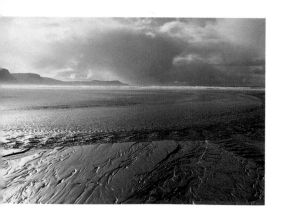
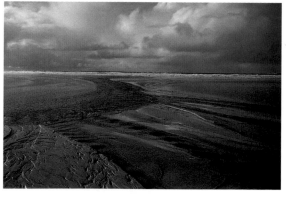

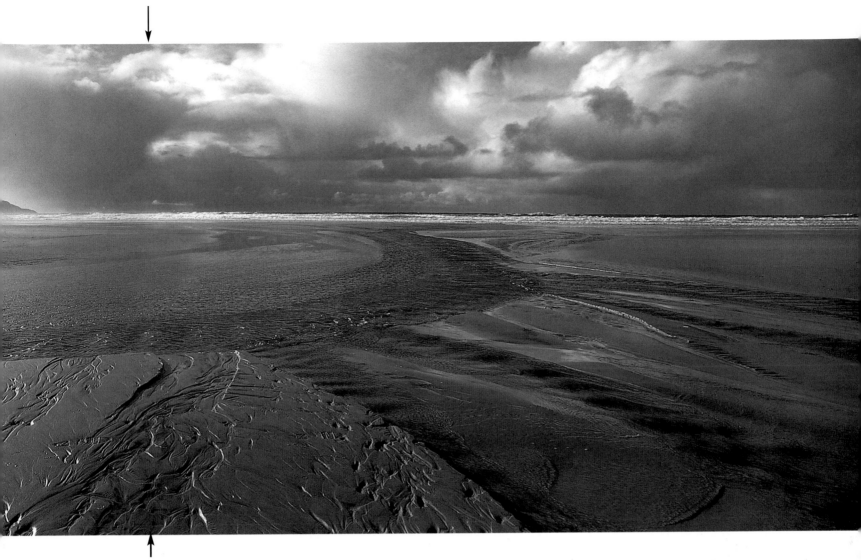

little sand spit, I adjusted Curves and Levels until the match on either side of the seam was perfect. Switching back to the right-hand (upper layer) image, it was then simply a matter of erasing the seam with a 65 pixel soft-edged brush to reveal parts of the layer below. Sometimes I erased a bit further than the seam to allow me to follow the line of a cloud or pattern in the sand. With the two colour-matched and (thanks to the shift lens) in perfect alignment, this made

for a seamless blend. The arrows indicate the point at which the top image ends.

I was still left with the problem of an excessively dark right-hand edge to the picture. While keen to retain the tonal characteristics of the picture (this is pretty much as I saw the light, after all), that right-hand edge just looked too much like vignetting – which it was. Rather than take the easy way out by cropping it, I clicked on Quick Mask

and then drew a gradient that followed the gradual darkening towards the edge of the frame. The new Alpha channel was dragged to the Make Selection button. I exited Quick Mask and then adjusted Levels in the selected area so that the edge was no longer quite as dark.

As it transpired, the canvas need only have been 276.5mm, and the remainder was cropped away before printing the inkjet proof.

# Appendix:
# You really want to do this for a living?

*Getting up early in the morning may be the least of your challenges!*

I often get letters and e-mails asking how to become a professional photographer. I'm sometimes tempted to reply that it is easy to become one – it's staying one that's the tough part. In truth, there are as many answers as there are practitioners, and the surest way to fail is to follow someone else's career path. Let's be clear about one thing: training, distinctions, past credits and qualifications cut no ice with a picture editor – you are judged by your work on his/her light box and will make the sale if your picture meets a need better than the others.

Business skills aside, the first prerequisites for success are passion for the subject and a need to take photographs. Different stock agents variously urge me to photograph domestic pets, Scottish castles and Highland Games, but my heart isn't in these and when I do try them the pictures are usually on the poor side of mediocre. They rarely sell and I devote my time instead to subjects I know and want to learn more about – although they may not always be very commercial. More important than a knowledge of photographic technique (merely the means to an end) is an understanding of the landscape or species you want to photograph. To become a better natural history photographer, first become a better naturalist. There then exists the possibility of moving beyond pictures that merely look nice to those that illustrate a point or have a story to tell, broadening their commercial appeal. You may not agree with some of the statements made elsewhere in this book concerning 'creative' photography and believe it should be about nothing more than pure, intuitive reaction, but it should be clear that by adopting the 'creative' frame of mind, you are forced to think more about what you are looking at. For a great deal of editorial usage, content has a higher status than simple appearance.

It seems that, almost every day, there are more and more of us wanting a slice of the photo market pie on either a full- or part-time basis. One of the consequences of this is that all the major picture

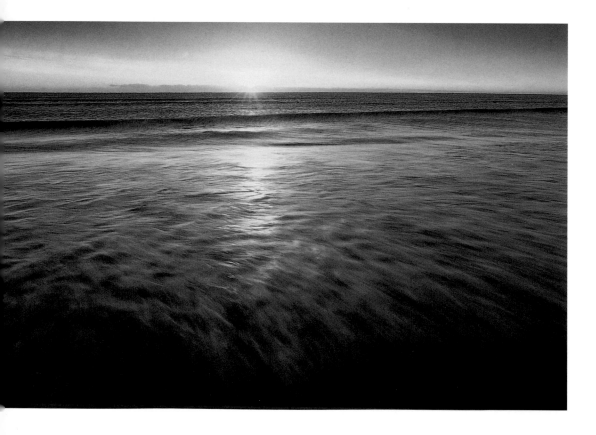

libraries are bursting at the seams with fine imagery and are incredibly selective about the new material they are willing to handle. It is a bit dispiriting to have most of your best work from a year's shooting rejected and to know that there is no prospect of it being represented by that library. Nevertheless, the rapid shift to on-line viewing is levelling the playing field for the photographer who markets his/her own stock, if the name is well enough known and the site relentlessly promoted. To this end, all photographers interested in self-marketing should request by-lines featuring their URL, rather than simply their name: www…com takes up very little additional space beside a picture.

The received wisdom is that outdoor photography is an extremely competitive field. It certainly is, but if you have a powerful competitive streak in you, your work is fresh and you have a head for business, you will have an advantage over many others wanting to join the profession. Sometimes the competition problem is overstated. Many names come and go, for whatever reasons; the process of turning professional and having very little income for several years is a major weeding-out factor, and it's not everyone who enjoys the pressure of running their own business. And while most choose to remain employed and practise their photography on a part-time basis, they are generally unable to undertake commissioned work or

to generate sales themselves and rely instead on picture libraries. While established photographers generally report a decline in stock income, this probably reflects a redistribution of sales rather than a shrinking market. The availability of royalty-free images, where the purchaser buys the right to unlimited use for a modest fee, has without doubt undermined some sectors of the stock business and could also account for a decline in stock returns. The fact remains, however, that there is an on-going demand for new, fresh imagery, that is imaginatively captured and engagingly presented. It doesn't really matter if you are competing with a hundred other photographers who all go to the same well-known locations and shoot stylistically similar pictures, if you are doing something different. Once you have found your own vision, competition is less of a concern.

In many industries traditionally concerned with producing raw materials, the concept of 'adding value' has taken root and photography is no exception. It may be in the form of producing fine art prints or postcards from the original transparency, or offering workshops based on your expertise. The route that relatively few photographers take is to add words to their pictures, to present a more finished product than others who simply supply picture sets. The golden rule for the editorial photographer is to make life as easy for the editor as possible. A well-

written text with relevant pictures is a more attractive proposal than pictures alone. Ideas can be promoted at the outset as inexpensive inkjet print layouts (see pages 148–9), variations can be tailored to different publications, and if there is interest, transparencies or digital files can then be submitted.

Books provide an excellent opportunity to showcase your work but, in this field, are notoriously poor earners for all but a few very well-known names. You may be tempted to self-publish, with potentially bigger returns, but there is always the possibility that the reason no publisher wanted to take on your book was because it was just no good or, at best, too limited in its appeal. Books are best regarded as a marketing tool with which you can introduce your work to new clients, as if they are any good they tend to be respected more than tearsheets of published work from magazines.

Ultimately, success in the business of photography is not just about having a fresh vision and competitive staying power: it is about how you get on with people. Editors have plenty of suppliers to choose from, but are more likely to pick up the telephone to someone they enjoy talking to, who is professional in their attitude and delivers on time. Be as creative in your personal and marketing skills as you are in the field with a camera and you can go a long way.

# Bibliography

Andrews, Malcolm, *Landscape and Western Art* (Oxford: Oxford University Press, 1999)

Benvie, Niall, *The Art of Nature Photography* (Newton Abbot: David & Charles, 2000)

Berry, Wendell, 'Life is a Miracle', *Orion*, vol. 19, no. 2, pp28– 39

Burroughs, William J. (et al), *Weather* (London: HarperCollins, 1996)

Clarke, Graham, *The Photograph* (Oxford: Oxford University Press, 1997)

Evening, Martin, *Adobe Photoshop 5.0 for Photographers* (Oxford: Focal Press, 1998)

Gleick, James, and Porter, Eliot, *Nature's Chaos* (London: Sphere Books, 1991)

Gruen, Lori, and Jamieson, Dale (eds), *Reflecting on Nature* (Oxford: Oxford University Press, 1994)

Huntington, Cynthia, *The Salt House* (Hanover: University Press of New England, 1999)

Jeffrey, Ian, *Photography* (London: Thames and Hudson, 1996)

Lopez, Barry, *About this Life* (New York: Vintage Books, 1998); includes essay 'Learning to See'

––*Crossing Open Ground* (London: Pan Books, 1989)

McKibben, Bill, *The End of Nature* (London: Viking, 1990)

–– 'The Problem with Wildlife Photography', *Doubletake*, Fall 1997, pp50– 56

Oelschlaeger, Max, *The Idea of Wilderness* (London: Yale University Press, 1991)

–– (ed), *The Wilderness Condition* (Washington DC: Island Press, 1992)

Rackham, Oliver, *The Illustrated History of the Countryside* (London: Seven Dials, 2000)

Schama, Simon, *Landscape and Memory* (London: HarperCollins, 1996)

Smout, T. C. (ed), *Scotland since Prehistory* (Aberdeen: Scottish Cultural Press, 1993)

Sontag, Susan, *On Photography* (London: Penguin Books, 1979)

Varley, Helen (ed), *Colour* (London: Marshall Editions Limited, 1988)

The following extracts are reproduced by kind permission of the copyright holders:

Page 14 from *Landscape and Western Art* by Malcolm Andrews (Oxford University Press); page 75 from *On Photography* by Susan Sontag (Penguin Books, London, 1979); page 86 from *Landscape and Memory* by Simon Schama (HarperCollins, London, 1996); page 103 from *Nature's Chaos* by James Gleick and Eliot Porter (Little, Brown, London); page 114 from *The Photograph* by Graham Clarke (Oxford University Press, 1997); page 115 from 'The Problem with Wildlife Photography' by Bill McKibben (*Doubletake* magazine, no. 10, Fall 1997); page 120 from 'Life is a Miracle' (Orion Society, v. 19, no. 2, p. 39).

# Website addresses

If you would like to register to receive updates to the information in this book, please e-mail me at:
**niall@niallbenvie.com**
  The following websites are of interest to both in-camera and digital workers. My own website is at:
**www.niallbenvie.com**

## EQUIPMENT, MATERIALS AND SOFTWARE MANUFACTURERS

**Adaptec** (Toast software for writing CD on a Mac): www.adaptec.com
**Adobe**, general site (Photoshop and PhotoDeluxe): www.adobe.com
**Adobe** (Photoshop information page): www.adobe.com/prodindex/photoshop/main.html
**Apple** (Macintosh G4 computers and iMac): www.apple.com
**Arca-Swiss** (ball heads): www.arca-swiss.com
**Canon** (camera equipment, tilt/shift and image-stabilizing lenses): www.canon.com
**Cokin** (filter holders and filters): www.cokin.co.uk
**Corel** (Ultimatte) KnockOut: www.corel.com
**Epson** (Stylus Photo inkjet printers, ink and papers): www.epson.com
**Formac** (Trinitron displays): www.formac.com
**Fuji** (films): www.fujifilm.com
**Fuji** (panoramic and rangefinder cameras): www.fujifilm.co.uk
**Fujitsu** (Pictrography printers): www.fujitsu-europe.com
**Gitzo** (tripods): www.gitzo.com
**Hasselblad Xpan** (panoramic camera): www.xpan.com
**Hewlett Packard** (inkjet printers): www.hp.com
**Imacon** (FlexTight film scanners): www.imacon.dk
**Kinesis** (beanbags): www.kinesisgear.com
**Kirk** (specialist accessories): www.kirkphoto.com
**Kodak** (Kodachrome): www.kodak.com
**Lee** (filter holders and filters): www.leefilters.com
**Linhof** (panoramic and large format cameras): www.linhof.net
**Live Picture** (image-editing software): www.livepicture.com
**LL Rue Photographic Equipment** (specialist gear): www.rue.com
**Lowepro** (camera packs): www.lowepro.com
**Manfrotto** (tripods): www.manfrotto.com
**Microsoft** (Internet Explorer, Internet Mail and News): www.microsoft.com
**Nicholas Hunter Ltd** (archival slide storage sheets and acetate sleeves): www.photofiling.com
**Nikon** (cameras, lenses, flashes and desktop film scanners): www.klt.co.jp/nikon
**Norman** (location flash):

www.normanflash.com
OpTech (neoprene camera straps): www.optechusa.com
Perfect Niche (Cradoc CaptionWriter): www.perfectniche.com
Polaroid (desktop film scanners and film writers): www.polaroid.com
Really Right Stuff (custom Arca-type plates and 90° bracket): www.reallyrightstuff.com
Sachtler (professional tripods and fluid heads): www.sachtler.com
Singh-Ray (graduated ND/colour-intensifying filters): www.singh-ray.com
Tamrac (equipment bags and backpacks): www.tamrac.com
The Vested Interest (photographers' waistcoats): www.vestedinterest.com
Wacom (graphics tablets): www.wacom.com

## Photographers
Ansel Adams: www.anseladams.com
Niall Benvie: www.niallbenvie.com
Phil Borges: www.philborges.com
Jack Dykinga: www.dykinga.com
Frans Lanting: www.lanting.com
George Lepp: www.leppphoto.com
Thomas Mangelsen: www.mangelsenonline.com
William Neill: www.williamneill.com
Colin Prior: www.colinprior.com
Galen Rowell: www.mountainlight.com
John Sexton: www.johnsexton.com
Art Wolfe: www.artwolfe.com

## Magazines
Outdoor Photographer: www.outdoorphotographer.com
Orion: www.orionsociety.org
Doubletake: www.doubletakemagazine.org

## Information sources
Christopher Gronbeck (sun position tables): www.susdesign.com/sunangle
McDonald Wildlife Photography (photography tours and workshops): www.hoothollow.com
Nature Photographers: www.naturephotographers.net
Photoalley: www.photoalley.com

Photonet: www.photo.net
Photoshot: www.photoshot.com
Pixl (digital colour management): www.pixl.dk

# Acknowledgements

While the life of an outdoor photographer may appear to be an isolated one, each picture results from the guidance and support of numerous different individuals, both directly and indirectly. Of the many I have worked with over the years during which I assembled the pictures and ideas for this book, I am especially grateful to:

My father, the late Donald Benvie, who did everything he could to develop my childhood interest in the natural world into an enduring passion.

In Scotland: Colin Baxter; the late Dr Gordon Burgess; Lorne Gill, Scottish Natural Heritage; Alban Houghton; Roddy McGeoch; Neil McIntyre; John MacPherson; Andy Reynolds; Charlie Self; John Walters, Scottish Natural Heritage; Stuart and Liz Young; and my ever-supportive family – wife Rachel, mother Nan, and sisters Aileen, Vivien and Dawn.

In Latvia: Zanete Andersone; Janis Ozolins.

In the Netherlands: Marianne van Oostrum; Mirelle de Ronde.

In Norway: Duncan and Sachiko Halley; Livar Ramvik.

In Poland: Drs Bogumila and Wlodzimierz Jedrzejewski; Dr Czeslaw Okolow; Jan and Stasha Piskur; Jan Walencik.

In the USA: Joe and Mary Ann McDonald.

My editors at David & Charles, Anna Watson and Freya Dangerfield, who allowed me more freedom than I could have hoped for in writing this book. And Diana Dummet, art editor, for organizing scanning when it was needed.

Adobe Systems Europe Ltd, who supplied Photoshop 5.0.

Calumet, Aberdeen Branch, for the loan of the Flextight scanner and Fuji S1 digital camera.

Brian Black for featuring in the digital camera photo.

Canon (UK) Ltd, who generously loaned equipment for an extended period.

Steve Bloom (www.stevebloom.com), for good advice on all things digital.

Andrew Gove, for keeping the office under control during this project.

Dr John Morrison, Aberdeen University, for guiding my reading on art history.

Dr James Morrison, for agreeing to appear in one of his own paintings.

Glyn Pritchard, for Web searching and stellar advice.

Dr Kenny Taylor, for introducing me to new environmental literature.

My readers, who were crucial in the process of refining ideas into final manuscript. My special thanks go to Roddy McGeoch, Sue Fogden and Dr James Morrison.

Finally, Scottish Natural Heritage kindly agreed to the early release of some commissioned work from the Beinn Eighe National Nature Reserve 50th Anniversary project, which appears in this book.

# Index

Illustrations are shown in *italic*